M. C. Escher

TASCHEN

HONGKONG KÖLN LONDON LOS ANGELES MADRID PARIS TOKYO

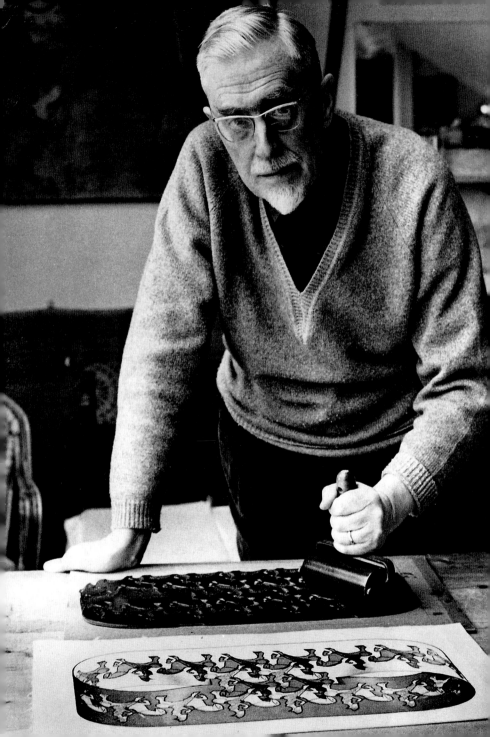

"Only those who attempt
the absurd will achieve the
impossible. I think it's in
my basement... let me go
upstairs and check."

« Seuls ceux qui se livrent
à l'absurde parviennent à
l'impossible. Je crois que
c'est au sous-sol : je monte
un instant pour vérifier. »

„Nur wer das Absurde
sucht, wird das Unmögliche
erreichen. Ich glaube, es ist
in meinem Keller ... lassen
Sie mich nach oben gehen
und nachsehen."

M. C. Escher

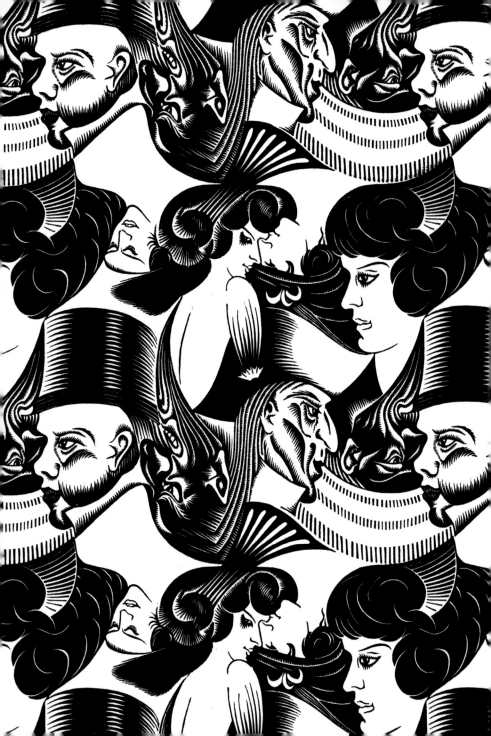

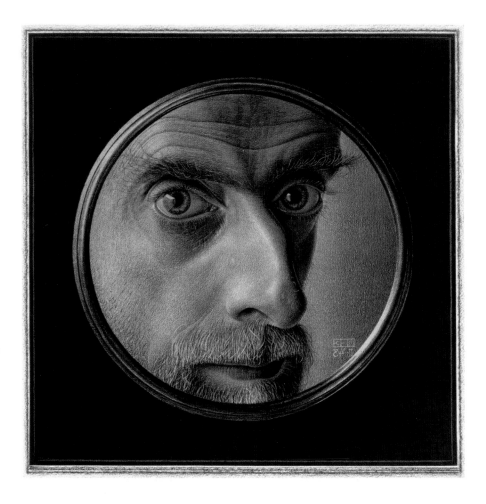

INTRODUCTION

Anyone who applies himself, from his early youth, to the practice of graphic techniques may well reach a stage at which he begins to hold as his highest ideal the complete mastery of his craft. Excellence of craftsmanship takes up all his time and so completely absorbs his thoughts that he will even make his choice of subject subordinate to his desire to explore some particular facet of technique. True enough, there is tremendous satisfaction to be derived from the acquisition of artistic skill and the achievement of a thorough understanding of the properties of the material to hand, and in learning with true purposefulness and control to use the tools which one has available – above all, one's own two hands!

I myself passed many years in this state of self-delusion. But then there came a moment when it seemed as though scales fell from my eyes. I discovered that technical mastery was no longer my sole aim, for I became gripped by another desire, the existence of which I had never suspected. Ideas came into my mind quite unrelated to graphic art, notions which so fascinated me that I longed to communicate them to other people. This could not be achieved through words, for these thoughts were not literary ones, but mental images of a kind that can only be made comprehensible to others by presenting them as visual images. Suddenly the method by which the image was to be presented became less important than it used to be. One does not of course study graphic art for so many years to no avail; not only had the craft become second nature to me, it had also become essential to continue using some technique of reproduction so that I could communicate simultaneously to a large number of my fellow men that which I was aiming at.

If I compare the way in which a graphic sheet from my technique period came into being with that of a print expressing a particular train of thought, then I realize that they are almost poles apart. What often happened in the past was that I would pick out from a pile of sketches one which it seemed to me might be suitable for reproduction by means of some technique that was interesting me at that moment in time. But now it is from amongst those techniques, which I have to some degree mastered, that I choose the one which lends itself more than any other, to the expression of the particular idea that has taken hold of my mind.

Nowadays the growth of a graphic image can be divided into two sharply defined phases. The process begins with the search for a visual form such as will interpret as clearly as possible one's train of thought. Usually a long time elapses before I decide that I have got it clear in my mind. Yet a mental image is something completely different from a visual image, and however much one exerts oneself, one can never manage to capture the fullness of that perfection which hovers in the mind and which one thinks of, quite falsely, as something that is "seen". After a long series of attempts, at last – when I am just about at the end of my resources – I manage to cast my lovely dream in the defective visual mould of a detailed conceptual sketch.

After this, to my great relief, there dawns the second phase, that is the making of the graphic print; for now the spirit can take its rest while the work is taken over by the hands.

In 1922, when I left the School of Architecture and Ornamental Design in Haarlem, having learnt graphic techniques from S. Jessurun de Mesquita, I was very much under the influence of this teacher, whose strong personality certainly left its mark on the majority of his pupils. At that period the woodcut(that is to say the cutting with gouges in a side-grained block of wood, usually pear) was more in vogue with graphic artists than is the case today. I inherited from my teacher his predilection for side-grained wood, and one of the reasons for

my ever-lasting gratitude to him stems from the fact that he taught me how to handle this material. During the first seven years of my time in Italy, I used nothing else. It lends itself, better than the costly end-grained wood, to large-sized figures. In my youthful recklessness I have gouged away at enormous pieces of pearwood, not short of three feet in length and perhaps two feet wide. It was not until 1929 that I made my first lithograph, and then in 1931 I tried my hand for the first time at wood-engraving, that is to say engraving with burins on an end-grain block. Yet even today the woodcut remains for me an essential medium. Whenever one needs a greater degree of tinting or colouring in order to communicate one's ideas, and for this reason has to produce more than one block, the woodcut offers many advantages over wood-engraving, and there have been many paints in recent years that I could not have produced had I not gained a thorough knowledge of the advantages of side-grained wood. In making a colour-print I have often combined both of these raised relief techniques, using end-grain for details in black, and side-grain for the colours.

The period during which I devoted such enthusiasm to my research into the characteristics of graphic materials and during which I came to realize the limitations that one must impose on oneself when dealing with them, lasted from 1922 until about 1935. During that time a large number of prints came into being (about 70 woodcuts and engravings and some 40 lithographs). The greater number of these have little or no value now, because they were for the most part merely practice exercises: at least that is how they appear to me now.

The fact that, from 1938 onwards, I concentrated more on the interpretation of personal ideas was primarily the result of my departure from Italy. In Switzerland, Belgium and Holland where I successively established myself, I found the outward appearance of landscape and architecture less striking than that which is particularly to be seen in the southern part of Italy. Thus I felt compelled to withdraw from the more or less direct and true-to-life illustrating of my surroundings. No doubt this circumstance was to a high degree responsible for bringing my inner visions into being.

On one further occasion did my interest in the craft take the upper hand again. This was in 1946 when I first made the acquaintance of the old and highly respectable black art technique of the mezzotint, whose velvety dark grey and black shades so attracted me that I devoted a great deal of time to the mastery of this copper-plate intaglio, a process that has today fallen almost entirely into disuse. But before long it became clear that this was going to be too great a test of my patience. It claims far too much time and effort from anyone who, rightly or wrongly, feels he has no time to lose. Up to the present I have, in all, produced no more than seven mezzotints, the last one being in 1951.

I have never practised any other type of intaglio. From the moment of my discovery, I have deliberately left etching and copper-plate engraving to one side. The reason for this can probably be traced to the fact that I find it preferable to delineate my figures by means of tone-contrast, rather than by linear contour. The thin black line on a white background, which is characteristic of etching and copper-engraving, would only be of use as a component part of a shaded area, but it is not adequate for this purpose. Moreover, with intaglio, one is much more tied to white as a starting point than is the case with raised relief and planography. The drawing of a narrow white line on a dark surface, for which raised relief methods are eminently suitable, is practically impossible with intaglio, while on the other hand, a thin black line on a white background can be satisfactorily achieved, albeit as a rather painstaking operation,

in woodcuts and wood-engravings.

By keenly confronting the enigmas that surround us, and by considering and analyzing the observations that I had made, I ended up in the domain of mathematics. Although I am absolutely innocent of training or knowledge in the exact sciences, I often seem to have more in common with mathematicians than with my fellow artists.

On reading over what I wrote at the beginning of this introduction, about the particular representational character of my prints, I feel it may be rather illogical to devote so many words to it, not only here but beside each separate reproduction as well. It is a fact, however, that most people find it easier to arrive at an understanding of an image by the round-about method of letter symbols than by the direct route. So it is with a view to meeting this need that I myself have written the text. I am well aware that I have done this very inadequately, but I could not leave it to anyone else, for – and here is yet another reason for my astonishment – no matter how objective or how impersonal the majority of my subjects appear to me, so far as I have been able to discover, few, if any, of my fellow-men seem to react in the same way to all that they see around them.

M. C. Escher

INTRODUCTION

Celui qui dès son enfance s'adonne passionnément à la technique graphique atteint un jour le stade où il considère la totale maîtrise de son métier comme un idéal. La recherche de perfection lui demande tellement de temps et de concentration qu'il soumet le choix du sujet au désir d'explorer une facette de sa technique. Il est vrai qu'acquérir un savoir-faire manuel, explorer les propriétés des matériaux à notre disposition ainsi qu'apprendre à nous servir des outils dont nous disposons – et en premier lieu de nos propres mains! – avec efficacité et maîtrise, tout ceci constitue une source de grande satisfaction.

Je me trouvais moi-même dans cet état d'illusion des sens pendant des années; puis vint le jour où j'eus une révélation. Je m'aperçus que la maîtrise de la technique n'était plus mon but car un autre désir me prenait, désir qui m'était jusqu'à lors demeuré inconnu. Il me venait à l'esprit des idées qui n'avaient rien à voir avec le métier de graveur, des idées qui me fascinaient tellement que j'éprouvais un fort désir de les communiquer. Il était impossible de les exprimer en paroles, elles n'appartenaient pas au domaine littéraire mais au figuratif et elles seraient compréhensibles seulement sous une forme visuelle. Le moyen devenait soudain moins important qu'auparavant; pourtant on ne fait pas impunément de la gravure pendant des années. Non seulement elle était devenue pour moi une seconde nature, mais il me semblait également indispensable d'utiliser une technique de reproduction qui permette de faire connaître mes intentions à beaucoup de personnes en même temps.

En comparant la naissance d'une gravure de ma période technique à celle d'une estampe dans laquelle j'avais exprimé une suite d'idées, je me rends compte que ces deux périodes sont presque opposées l'une à l'autre. Avant il m'arrivait de choisir dans une pile de croquis celui qui me semblait se prêter le mieux à la technique à laquelle je m'intéressais particulièrement à ce moment-là. A présent, par contre, je choisis parmi les techniques que j'ai apprises celle qui se prête le mieux à l'expression de l'idée qui me captive.

Dès lors, la naissance de l'estampe se divise en deux phases distinctes. Le processus commence par la recherche de la forme visuelle qui interprétera aussi clairement que possible nos pensées. Elle met généralement beaucoup de temps avant de s'imposer à notre esprit. Mais un concept se distingue fort d'une image visuelle et même avec beaucoup d'efforts je ne crois pas qu'il soit possible d'atteindre la perfection qui vit dans notre esprit et que, à tort, nous croyons «voir». Plus ou moins désespérés après de multiples essais, nous donnons corps à notre beau rêve sous la forme visuelle mais imparfaite d'un croquis détaillé. Ensuite commence la deuxième phase et notre esprit, soulagé, se repose pendant que nos mains prennent la relève: c'est la réalisation de la gravure.

En 1922, en quittant l'Ecole d'Architecture et des Beaux Arts de Haarlem où j'avais suivi les cours des techniques graphiques dispensés par S. Jessurun de Mesquita, je subissais l'influence de ce maître dont la forte personnalité laissait sa marque sur la plupart de ses élèves. En ce temps là, la gravure sur bois de fil (bois, généralement de poirier, pris dans le sens de la longueur, taillé à la gouge) était plus à la mode parmi les graveurs qu'aujourd'hui. J'ai hérité de mon professeur la prédilection pour le bois de fil, et une des raisons pour lesquelles je lui suis éternellement reconnaissant est qu'il m'a appris à travailler cette matière. Pendant les sept premières années de mon séjour en Italie, je m'en suis servi exclusivement. Elle se prête mieux au grand format que le coûteux bois de bout. J'ai travaillé à la gouge, avec une verve juvénile, des morceaux énormes de bois de poirier de plus de 70 cm de long sur presque 50 cm de large. Ce n'est qu'en 1929 que je fis ma premiè-

re lithographie et en 1931 que je me hasardai à la gravure sur bois de bout (graver au burin un morceau de bois de bout). Aujourd'hui encore, la gravure sur bois de fil me reste indispensable. Elle présente beaucoup d'avantages par rapport à la gravure sur bois de bout si on veut util éter ses idées, ce en quoi on a besoin de plusieurs planches, et il y a beaucoup de gravures que je n'aurais pu faire ces dernières années si je n'avais pas connu tout l'intérêt du bois de fil. Souvent j'ai combiné ces deux procédés de gravure en relief en utilisant du bois de bout pour les détails en noir et du bois de fil pour les couleurs.

La période pendant laquelle j'ai expérimenté avec ardeur les particularités des matériaux en découvrant les limites qu'elles imposent se situe entre 1922 et environ 1935. Au cours de ces années, une grande quantité de gravures ont vu le jour (à peu près soixante-dix gravures sur bois de fil et de bout et une quarantaine de lithographies). Beaucoup n'ont que peu ou pas du tout de valeur car il me semble aujourd'hui qu'elles étaient des «exercices de doigté».

Le fait qu'à partir de 1938 j'accordai de plus en plus d'attention à l'interprétation de mes idées personnelles fut d'abord la conséquence de mon départ d'Italie. En Suisse, en Belgique et aux Pays-Bas, où je m'installai successivement, l'aspect extérieur des paysages et de l'architecture m'attirait moins qu'en Italie du Sud. Par la force des choses, j'étais obligé de m'éloigner d'une reproduction directe et fidèle de la nature qui m'entourait. Cette circonstance donnait sans doute une forte stimulation à la naissance d'images intérieures.

Une fois encore, l'intérêt pour le métier prit le dessus, quand en 1946 je fis connaissance, pour la première fois, de la vieille et respectable technique de la manière noire ou du mezzotinte. Ces teintes de gris foncé velouté et de noir m'enchantaient au point que je consacrai beaucoup de temps à m'approprier ce procédé de gravure en

creux sur cuivre, presque totalement tombé en désuétude. Bientôt, il devint clair qu'il mettrait ma patience à rude épreuve. Ce procédé demande trop de temps et d'énergie à quelqu'un qui croit, à tort ou à raison, ne pas en avoir à perdre. Jusqu'à présent je n'ai fait que sept mezzotintes au total, dont le dernier en 1951.

Je n'ai jamais employé d'autres techniques de gravure en creux. Dès le début de mes recherches, j'ai évité consciemment l'eau forte et la gravure sur cuivre. La raison est, je suppose, que je préfère les contrastes de nuances aux traits de contour. Le fin tracé noir sur fond blanc qui caractérise l'eau forte et la gravure sur cuivre aurait seulement de la valeur comme partie d'une surface hachurée mais ne conviendrait pas à mon dessein. La gravure en creux, beaucoup plus que la gravure en relief, astreint l'artiste au blanc comme point de départ. Tirer un mince trait blanc sur fond noir, ce à quoi le procédé en relief se prête exceptionnellement, est presque impossible à faire avec la gravure en creux; par contre, un fin trait noir sur une surface blanche, quoique difficile à réaliser, peut être obtenu d'une manière satisfaisante sur bois de fil ou de bout.

En exposant mes sens aux énigmes de l'univers, en réfléchissant à ces sensations et en les analysant, je m'approche du domaine des mathématiques. Bien que je manque totalement de connaissances et de formation dans le domaine des sciences exactes, je me sens plus proche des mathématiciens que de mes collègues artistes.

En relisant le début de cette introduction sur le caractère typiquement visuel de mes gravures, il me semble inconséquent d'avoir été si long et surtout d'avoir donné une explication de chaque reproduction. Il est vrai, cependant, que la plupart des gens comprennent plus aisément une image par l'intermédiaire d'un texte que par le contact de l'image elle-même. J'ai écrit le texte moi-même pour répondre à ce besoin; tout en ayant conscien-

ce de ses imperfections, je n'ai pu en laisser le
soin à un autre car, autre sujet d'étonnement, bien
que la majorité des sujets me semblent objectifs
et impersonnels, je n'ai pu trouver parmi mes
semblables quelqu'un qui réagisse de la même fa-
çon que moi au monde extérieur.

M. C. Escher

EINLEITUNG

Wer sich von klein auf leidenschaftlich der Beschäftigung mit graphischen Techniken widmet, dem kann es passieren, daß er die vollkommene Beherrschung dieser Techniken als sein höchstes Ideal ansieht. Das schöne Handwerk nimmt seine gesamte Zeit in Anspruch und verlangt seine ganze Aufmerksamkeit in solchem Maße, daß er sogar die Wahl des Gegenstandes von seinem Drang, eine bestimmte Facette der Technik zu untersuchen, abhängig macht und ihm unterordnet. Es schenkt einem tatsächlich höchste Befriedigung, sich handwerkliches Können anzueignen, die Eigenschaften des uns zur Verfügung stehenden Materials gründlich kennenzulernen und die Werkzeuge, über die wir verfügen – an erster Stelle unsere eigenen Hände! –, zweckmäßig und beherrscht gebrauchen zu lernen.

Ich persönlich habe mich jahrelang in einem derartigen Zustand der Sinnestäuschung befunden. Aber dann kam der Zeitpunkt, an dem es mir wie Schuppen von den Augen zu fallen schien. Ich merkte, daß nicht mehr die Beherrschung der Technik mein Ziel war, weil ich von einem anderen Verlangen ergriffen wurde, dessen Existenz mir bis dahin unbekannt war. In mir kamen Ideen auf, die mit dem graphischen Bereich nichts zu tun haben, Vorstellungen, die mich so fesselten, daß ich sie unbedingt anderen mitteilen wollte. Dies konnte nicht mit Worten geschehen, denn es waren keine literarischen Gedanken, sondern typische Denk-"Bilder" die für andere nur verständlich werden können, wenn man ihnen eine Abbildung zeigt. Die Methode, nach der man ein Bild anfertigt, verlor plötzlich an Bedeutung. Selbstverständlich beschäftigt man sich nicht umsonst jahrelang mit Graphik. Das "Handwerk" war mir nicht nur zur zweiten Natur geworden, sondern schien auch notwendig zu sein, um weiterhin eine Vervielfältigungstechnik anzuwenden, die es ermöglichte, vielen Menschen gleichzeitig meine Absichten begreiflich zu machen.

Wenn ich die Entstehungsweise eines graphischen Blattes aus meiner Technik-Periode mit der eines Druckes vergleiche, in dem ein bestimmter Gedankengang zum Ausdruck gebracht wird, scheint es mir, als würden sie fast im Gegensatz zueinander stehen. Früher passierte es häufig, daß ich aus einem Stapel Skizzen eine aussuchte, die mir für eine bestimmte Art der Ausführung geeignet schien, welche in diesem Moment mein besonderes Interesse genoß. Heute wähle ich jedoch aus den Techniken, die ich mir angeeignet habe, eine aus, die sich mehr als jede andere für die Darstellung eines bestimmten, mich fesselnden Gedankens anbietet.

Die Entstehung einer graphischen Darstellung besteht seitdem aus zwei streng voneinander getrennten Phasen. Der Arbeitsprozeß beginnt mit der Suche nach einer visuellen Norm, die unseren Gedankengang möglichst deutlich überträgt. Meistens dauert es lange, bis wir glauben, daß sie uns klar vor Augen steht. Aber ein Gedanke ist etwas völlig anderes als ein visuelles Bild. Und wie sehr wir uns auch anstrengen, so gelingt es doch niemals, die Vollkommenheit, die uns im Geiste vorschwebt und die wir zu Unrecht glauben zu "sehen", auf perfekte Weise zu verwirklichen. Nach einer langen Reihe von Versuchen gießen wir schließlich, mit unserer Weisheit mehr oder weniger am Ende, den schönen Traum in die unzulängliche sichtbare Form einer detaillierten Entwurfszeichnung. Danach beginnt, wie zur Erholung, die zweite Phase: die Anfertigung des graphischen Druckes, während der unser Geist ausruhen kann und unsere Hände die Arbeit übernehmen. Als ich 1922 die Schule für Architektur und dekorative Künste verließ, in der mich S. Jessurun de Mesquita in den graphischen Techniken unterrichtet hatte, befand ich mich unter starkem Einfluß dieses Lehrers, dessen ausgeprägte Persönlichkeit übrigens den meisten seiner Schüler ihren Stempel aufdrückte. Zu jener Zeit

war der Holzschnitt (das Schneiden mit Hohleisen in eine meistens aus Birnbaum bestehende Langholzplatte) bei den Graphikern mehr in Mode, als es heute der Fall ist. Die Vorliebe meines Lehrers für Langholz habe ich übernommen, und einer der Gründe für meine bleibende Dankbarkeit ihm gegenüber besteht darin, daß er mir den Umgang mit diesem Material beibrachte. Während der ersten sieben Jahre meines Aufenthalts in Italien habe ich ausschließlich damit gearbeitet. Es eignet sich, mehr als das kostbare Hirnholz, für große Formate. Riesige Birnbaumplatten, die über 70 cm lang und fast 50 cm breit waren, habe ich damals in jugendlichem Überschwang mit dem Hohleisen bearbeitet. Erst 1929 fertigte ich meine erste Lithographie an, und 1931 wagte ich mich zum ersten Mal an den Holzstich (das Gravieren mit Sticheln in Hirnholzblöcke). Aber auch heute noch ist der Holzschnitt für mich ein unverzichtbares Medium. Sobald man für die Übertragung seiner Idee mehrere Farben zu benötigen glaubt und deshalb mehr als einen Holzstock anfertigen muß, bietet er gegenüber dem Holzstich viele Vorteile. So manchen Druck aus den letzten Jahren hätte ich nicht verwirklichen können, wenn ich die Vorzüge des Langholzes nicht von Grund auf kennengelernt hätte. Des öfteren habe ich in einem Mehrfarbendruck diese beiden Hochdruckverfahren kombiniert und Kopfholz für die Details in Schwarz und Langholz für die Farben benutzt.

Die Periode, in der ich mich mit Begeisterung auf die Untersuchung der Eigenschaften von graphischen Materialien stürzte und mir der Beschränkungen bewußt wurde, die man sich dabei auferlegen muß, dauerte von 1922 bis ungefähr 1935 an. Während dieser Zeit entstanden zahlreiche Drucke (ungefähr 70 Holzschnitte und -stiche und etwa 40 Lithographien). Der größte Teil von ihnen hat nur noch wenig oder gar keinen Wert mehr, weil es meistens "Fingerübungen" waren – zumindest machen sie heute diesen Eindruck auf mich.

Der Grund dafür, daß ich mich ab 1938 immer stärker auf die Übertragung persönlicher Ideen konzentrierte, war in erster Linie die Folge meines Fortgangs aus Italien. In der Schweiz, in Belgien und den Niederlanden, wo ich mich nacheinander aufhielt, berührten mich die äußeren Erscheinungsformen der Landschaft und Architektur weniger, als sie das vor allem im Süden Italiens getan hatten. Notgedrungen mußte ich mich deshalb von einer mehr oder weniger direkten und naturgetreuen Wiedergabe meiner Umgebung entfernen. Dieser Umstand stimulierte zweifellos in starkem Maße die Entstehung von inneren Bildern.

Ein einziges Mal gewann mein Interesse für das Metier doch noch die Oberhand. Das war, als ich 1946 zum ersten Mal mit der alten, ehrwürdigen Technik der Schabkunst, der Mezzotinto, in Berührung kam, deren samtige dunkelgraue und schwarze Farbtöne mich dermaßen reizten, daß ich der Aneignung dieses heute kaum noch gebräuchlichen Kupfertiefdruckverfahrens viel Zeit widmete. Aber schon bald zeigte sich, daß es meine Geduld auf eine zu harte Probe stellt. Es verlangt zuviel Zeit und Einsatz von jemandem, der zu Recht oder Unrecht glaubt, daß er keine Zeit verlieren darf. Bis heute fertigte ich insgesamt nur sieben Mezzotinti an, das letzte im Jahre 1951.

Ein anderes Tiefdruckverfahren habe ich niemals angewandt. Vom ersten Moment meiner Selbständigkeit an habe ich die Radierung und den Kupferstich ganz bewußt beiseite gelassen. Der Grund dafür liegt wahrscheinlich in der Tatsache, daß ich eine Figur lieber durch Farbkontraste als durch Linienkonturen begrenze. Die dünne schwarze Linie auf weißem Grund, die die Radierung und den Kupferstich kennzeichnet, wäre für mich nur als Bestandteil einer schraffierten Fläche von Bedeutung und ist somit nur unzureichend motiviert. Außerdem ist man beim Tiefdruck, in stärkerem Maße als beim Hoch- und Flachdruck, auf die Farbe Weiß als Ausgangsbasis

angewiesen. Die Anbringung einer schmalen wei-
ßen Linie auf einem dunklen Grund, zu der sich
Hochdruckverfahren ausgezeichnet eignen, ist im
Tiefdruck nahezu unmöglich, während im umge-
kehrten Fall eine dünne schwarze Linie auf weißem
Grund, wenn auch mit etwas Mühe verbunden,
durchaus im Holzschnitt und -stich ausgeführt
werden kann.

Wer sich über etwas wundert, ist sich eines
Wunders bewußt. Indem ich auf sinnliche Weise
den Rätseln, die uns umgeben, aufgeschlossen
gegenüberstehe und meine Beobachtungen über-
denke und analysiere, komme ich mit dem Gebiet
der Mathematik in Berührung. Obwohl ich über
keinerlei exakt-wissenschaftliche Ausbildung und
Kenntnisse verfüge, fühle ich mich oft mehr mit
Mathematikern als mit meinen eigenen Berufs-
kollegen verwandt.

Wenn ich lese, was ich zu Beginn dieser
Einleitung über den typischen Bild-Charakter mei-
ner Drucke schrieb, scheint es mir doch inkonse-
quent zu sein, ihm so viele Worte zu widmen, und
zwar nicht nur an dieser Stelle, sondern zudem
noch bei jeder einzelnen Reproduktion. Aber es ist
eine Tatsache, daß die meisten Menschen pro-
blemloser durch den Umweg über Buchstaben als
auf direktem Wege ein Bild verstehen können. Um
diesem Bedürfnis entgegenzukommen, habe ich
die Beschreibungen selbst zusammengestellt. Ich
bin mir der unzulänglichen Weise, in der ich dies
getan habe, durchaus bewußt. Trotzdem konnte
ich diese Aufgabe keinem anderen überlassen,
denn – und das ist wieder ein Grund, der mich in
Erstaunen versetzt – wie objektiv und unpersön-
lich die meisten meiner Themen mir auch vor-
kommen, so habe ich doch festgestellt, daß kaum
einer meiner Mitmenschen auf dieselbe Weise wie
ich von dem, was man in unserer Umwelt betrach-
ten kann, berührt wird.

M. C. Escher

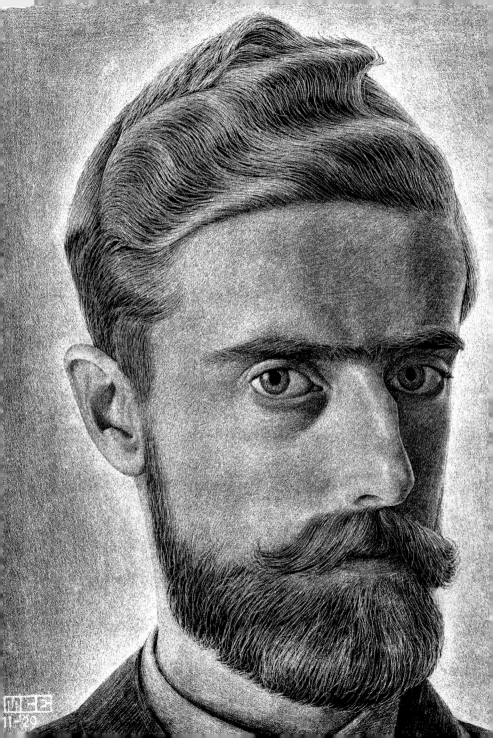

BIOGRAPHY

The Dutch artist Maurits C. Escher (1898-1972) is one of the world's most famous graphic artists, and can be regarded as the "Father" of modern tessellations, i.e. regular divisions of the plane. Greatly admired by millions of people he is most loved for his so-called impossible structures and transformation prints, which include Ascending and Descending, Relativity, Metamorphosis I, II and III, Sky & Water I and Reptiles. M.C. Escher was a master at lino and wood cuts and also produced many superbly crafted landscapes dating from the period he spent living and travelling in Italy.

He was a draftsman, book illustrator, tapestry designer, and muralist, but his primary work was as a printmaker. His genius lay in his outstanding ability to explore mathematical ideas in his art, such as the logic of space, regular divisions of the plane, paradoxes, and impossible figures, often balancing opposing concepts, such as order and disorder, high and low, close by and far away, up and down, etc.

During his life, he became increasingly obsessed with filling the plane with pictures that did not overlap or leave spaces. Aged 68, he stated, "Filling the plane has become a real mania to which I have become addicted and from which I sometimes find it hard to tear myself away." Here is his story.

EARLY YEARS. Born on 17 June 1898, in Leeuwarden, Holland, Escher was brought up by his father, George Escher, a civil engineer, and his second wife Sarah, the daughter of a government minister. He was the youngest of four sons. The family lived in a grand house named "Princessehof," which would later become a museum and host exhibitions of M.C. Escher's works.

Mauritz, his parents called him Mauk, spent his youth (1903-1918) in Arnhem where he went to both elementary and secondary school. Escher received his first instruction in drawing at secondary school from F.W. van der Haagen, who noticed he had a liking for pen and ink drawings and taught him how to make linocuts. He became good at it and sent some to the best-known graphic artist at the time, Roland Holtz, who was impressed and suggested he switch to wood.

His marks in secondary school were poor except in drawing and as a result he developed a deep interest in printing techniques and graphic work in general. Escher failed his final exams in history, constitutional organizations, political economies and bookkeeping, and therefore never officially graduated, so Holtz suggested he become an architect!

In 1918, Escher began private lessons and studies in architecture at the Higher Technology School in Delft, but soon after was forced to stop, due to poor health and being rejected for military service in 1919. During this difficult period, he did many drawings, and also began using woodcuts as a medium. Escher's first works date from this period; they include his earliest surviving work, a portrait of his father George.

Aspiring to be an architect, Escher enrolled in the School for Architecture and Decorative Arts in Haarlem. He showed his nature-drawing teacher, Samuel Jessurun de Mesquita, some of his linocuts. Immediately, Mesquita recognised his pupil's potential and helped him to change his studies from architecture to drawing and printmaking. He rapidly developed his skills especially in woodcutting and produced work of startling maturity. He and Mesquita became lifelong friends. Escher was devastated when his friend was taken to a concentration camp and executed. De Mesquita taught him all he knew of woodcut printing techniques, gave him space to develop, and encouraged him greatly.

In 1921, Escher went with his family to the French Riviera and to Rome, where he drew detailed drawings of cacti and olive trees and sought

out dramatic vistas to sketch from elevated vantage points. Around this time, he started to experiment with subjects central to his later work: mirror images, crystalline shapes and spheres. These subjects can be found in the woodcuts that he produced for a humorous booklet called "Flor de Pascua" [Easter Flower] by A.P. van Stolk. Moreover, in the same year, Escher's woodcut print St. Francis (Preaching to the Birds) was his first print to sell in large numbers.

ITALY AND SPAIN. After finishing school, Escher set out for Italy in search of new inspiration. After only a couple of weeks in Florence, he went on to San Gimignano, Volterra and Siena, where he did a great deal of serious drawing. He spent the spring of 1922 roaming the Italian countryside, drawing landscapes, plants, and even insects. Returning home in June, he quickly realised that it was no longer a productive environment for his work and grabbed the opportunity to go to Spain with friends on a freighter. He visited the Alhambra, a fourteen-century Moorish palace in Granada, saw examples of Arabic decorative styles, gained a fascination with the regular Division of the Plane, and went on to produce 'Eight Heads in 1922', his first woodcut of this kind. It was a hint of things to come.

His ongoing journey took him back to Italy, where he settled in Siena for a few months enjoying himself immensely and working very hard. Escher also stayed in Ravello, where he met and fell in love with his future wife Jetta Umiker, the daughter of a Swiss industrialist. Returning to Siena he held his first one-man show in August 1923, a milestone event in his artistic career. Escher also held his first one-man show in his homeland of Holland in February 1924.

Escher married Jetta Umiker in 1924, and the couple settled in Rome to raise a family. It is a measure of Escher's growing fame that both King Emmanuel of Italy and Mussolini attended the christening of their son George in 1926. They resided in Italy until 1935. During these 11 years, the main subjects of Escher's art were Rome and the Italian countryside. He often spent the spring and summer months travelling throughout the country to make drawings. He produced some of his most memorable landscape work; many of which were drawn from dizzying angles with amazing perspectives.

Escher often created enigmatic spatial effects by combining various, sometimes conflicting, vantage points, such as looking up and down at the same time. He often made these effects more dramatic through his treatment of light, involving stark contrasts of black and white. In 1925 he produced what was really his first tessellation. It was a block print of 'lions' in which the subject interlocked and covered the plane.

Living in Rome, happy with his wife and child, Escher had a number of productive years in the late 1920s. He exhibited his works in many shows in Holland, and by 1929 was so popular that he was able to hold five shows in Holland and Switzerland that year. It was during this period that his pictures of striking landscapes and commercial illustrations were first labelled as mechanical and "reasoned". Arthur their second son was born in December 1928.

Escher suffered from fragile health during the early thirties but managed to publish the volume XXIV Emblemata (1932). In 1933, he sold some prints to the Rijksmuseum in Amsterdam and completed others for the book The Terrible Adventures of Scholastica. His print Nonza won third prize at the Exhibition of Contemporary Prints at the Art Institute of Chicago, and became the first Escher work to be purchased by an American museum.

METAMORPHOSIS – A turning point in Escher's work. Growing political turmoil however forced them to move to Switzerland in 1935. He

soon began to miss the striking landscapes of southern Italy. As a result in 1936 Maurits and Jetta took a sea trip along the coasts of Italy and France to Spain, where they visited the Alhambra for the second time. The trip began on the 26 April 1936, and during the next two months they made numerous sketches from which to work from in the future.

This would prove a pivotal point in Escher's work - he moved from landscapes to 'mental imagery', to graphic works and tilings. The idea of "metamorphosis", one shape or object turning into something completely different, had in fact been one of Escher's favourite themes since the 1920s. But after studying the elaborate tile work found in the Alhambra again Escher became truly fascinated with order and symmetry and tessellations. In his words it was, "...the richest source of inspiration I have ever tapped".

In the late 1930s Escher developed "the regular division of the plane", so-called "tessellations", which are arrangements of closed shapes that completely cover the plane without overlapping and without leaving gaps. Escher was particularly interested in the way the shapes interact with each other and he delighted in replacing the abstract patterns of Moorish tiles with recognizable figures. He experimented with many different motifs such as weightlifters, camels, squirrels, and birds. In 1937 he used this concept to make his renowned Metamorphosis print, which showed a city block transforming into a little human figure.

In mid-1937, the Escher family resettled in Brussels, and in October he showed some of his plane-filling tessellations to his brother Beer, a professor of geology. Beer drew his attention to the similarity between his brother's woodcuts and crystallography, and sent his brother a list of articles on the subject. One was by Professor George Pólya in which he laid out the 17 possible wallpaper designs graphically as sketches. He stated he thought an artist could make use of this knowledge. Escher was astounded and immediately cut 'development 1' and sent it to him.

Escher continued his 'crystallographic' experiments throughout 1938; one of his most popular prints Day and Night was made then. In 1939, Escher completed Metamorphosis 2, his largest print ever, measuring 3.9 meters by 19 cm. This acclaimed work showed 10 transformations. A further experiment with tilings was of a swimming fish carved onto a Beachwood sphere, which he carried with him as his talisman for the rest of his life.

In 1941 the German invasion of Belgium led the Escher family to move back to Baarn in his homeland of Holland. He learned that Samuel de Mesquita, his formative teacher and a Jew had been taken away and killed by the Nazis. This affected Esher deeply and when it came to transferring Mesquita's artwork to the Stedelijk Museum in Amsterdam he secretly kept one of his sketches, that of a German boot. After the war he took part in an exhibition of artists that had not supported the Nazi regime. This lead to several commissions; one of them was 400 copies of one of his works for use in schools. The famous Reptiles (1943), done in this period, depicts a tiny crocodile crawling out of a tessellation and going over some books. He numbered all of his tessellations and by his death had produced 137.

At the end of the war Escher became interested in a new printing technique - mezzotint. One of his finest examples is Dewdrop (1948), which demonstrates the subtle and delicate lines of the technique. In 1949 in an exhibition in Rotterdam with two other artists, Escher not only presented his works, he also demonstrated his techniques. This led to good sales of his prints including the huge Metamorphosis II.

GROWING FAME. His popularity grew to such an extent that in 1949–1950 people were commis-

sioning him for more unusual services: he designed a tapestry for a weaver, and Philips of Holland commissioned him to design a ceiling decoration for their 60th anniversary. In the USA however only specialist print collectors knew of his work. In 1951 Escher created the famous lithograph House of Stairs.

He gained recognition in the USA and worldwide, when two articles appeared in the magazines Time and Life in 1951. In the wake of his publicity, there was a great boost in orders for his work, and his services as a lecturer were suddenly in demand. He enchanted audiences artistic and scientific with his visions. In 1954, he held his own first major American exhibition in the Whyte Gallery, Washington D.C, a significant factor in his growing popularity and success. Escher was an unsuspecting celebrity. He was quite surprised when the Queen of Holland awarded him a Knighthood of the Order of Oranje Nassau.

In 1956–1958 Escher's work took started to show a new trend. It can be seen in Smaller and Smaller (1956) and in Whirlpools (1957) and in Snakes. He was searching for a technique for expressing infinity within the limits of the print. Prior to 1958, Escher's work showed objects shrinking toward the centre of the print, after 1958 the objects in such prints shrunk towards the edges. This change came about in part due to an article he read by the Canadian mathematician Coxeter of Ottawa, which illustrated a system where the scale of the plane-filling motif was reduced proportionally to its distance from the centre of the circle.

Escher got the opportunity in 1959 to lecture on symmetry to an international group of crystallographers in England, which brought his work closer to mathematicians than ever before. Friends of Escher gave him an article by Roger Primrose describing 'impossible objects', in which Esher's earlier work is mentioned. This inspired him to produce the famous Ascending and Descending

(1960), which is based on the endless stairway described in the article.

In 1960 Esher published his first book called Grafiek en Tekeningen, in which he describes 76 of his works. The book attracted the attention of crystallographers worldwide and Escher lectured in many countries including England, Russia, Canada and the United States. A high point was his lecture to the Cambridge Crystallographers' Meeting in August 1960 in Cambridge (UK). 1960 was a very successful year, artistically and commercially.

Esher's periodic (tiling) work became quite popular in the late 50s and early 60s, which led to several books and more lectures. Unfortunately, in 1964 Escher fell ill and could not fulfil his lecturing engagements in North America. Nevertheless, in March 1965 Escher was awarded the cultural prize of the city of Hilversum. Then 'Symmetry Aspects of M.C. Escher's Periodic Drawings' by the crystallographer Caroline H. MacGillavry, was published in August of 1965. In 1968 he had exhibits in Washington, D.C. at the Mickelson Gallery and The Hague at the Gemeentemuseum. Escher went on to design 'Metamorphosis III' for the post office in The Hague, which was unveiled on Feb 20, 1969.

By 1970 Escher's health was failing and his wife, who had never been happy in Baarn, moved back to Switzerland forever. He continued with his drawings and woodcuts. He lived to see a comprehensive book about his life published not only in Dutch, but also in English, bearing the title The World of M.C. Escher.

Escher died in a home for old artists on 27th March 1972 at the age of 73. During his lifetime, he made 448 lithographs, woodcuts and wood engravings and over 2000 drawings and sketches. He played with architecture, perspective and impossible spaces. His art continues to amaze and wonder millions of people around the world due

to its freshness, fancifulness, and its depiction of reality as wondrous, comprehensible and fascinating.

BIOGRAPHIE

Originaire des Pays-Bas, Maurits C. Escher (1898-1972) est l'un des plus célèbres artistes graphiques, considéré comme le père des pavages modernes (divisions régulières du plan). Faisant l'admiration de millions de personnes, son œuvre est surtout appréciée pour ses structures et transformations dites impossibles, dont Ascendant et descendant, Relativité, Métamorphose I, II et III, Ciel et eau I et Reptiles. M.C. Escher dominait pleinement la gravure sur linoléum et sur bois, et il est l'auteur de splendides paysages conçus lors de ses séjours et voyages en Italie.

Il est à la fois dessinateur, illustrateur de livres, créateur de tapisseries et peintre mural, mais il est avant tout graveur. Tout son génie tient à sa capacité de tirer parti de principes mathématiques comme la logique spatiale, les divisions régulières du plan, les paradoxes et les figures impossible, en combinant souvent des concepts contraires comme l'ordre et le désordre, le haut et le bas, la distance et la proximité, etc.

Tout au long de sa vie, son obsession de remplir le plan avec des images qui ne se chevauchent pas et qui ne laissent pas d'espaces-vides n'a pas cessé de croître. À l'âge de 68 ans, il déclare : « Le remplissage du plan est devenu une véritable manie dont je suis dépendant et dont j'ai parfois du mal à m'extraire. » Voici son histoire.

LES DÉBUTS. Né le 17 juin 1898, à Leeuwarden (Pays-Bas), Escher est élevé par son père, George Escher, ingénieur civil, et sa seconde épouse Sarah, fille d'un ministre. Il est le cadet de quatre garçons. La famille vit dans une grande demeure baptisée « Princessehof », laquelle deviendra plus tard un musée et accueillera des expositions de travaux de M.C. Escher.

Maurits, que ses parents surnomment Mauk, passe son enfance (1903-1918) à Arnhem, où il va à l'école primaire et secondaire. Escher suit ses premiers cours de dessin au collège de la main de F.W. van der Haagen, qui remarque son penchant pour les dessins à l'encre et lui apprend la gravure sur linoléum. Il s'avère doué en la matière et envoie certaines œuvres à l'artiste graphique le plus réputé du moment, Roland Holtz, qui est impressionné et lui suggère de passer au bois.

Ses résultats scolaires au collège sont médiocres, sauf en dessin ; Escher s'intéresse alors de façon poussée aux techniques de gravure et aux arts graphiques en général. Comme il échoue aux examens finaux en histoire, organisations constitutionnelles, économie politique et comptabilité, il n'obtient pas de diplôme officiel. Holtz lui conseille alors de devenir architecte !

En 1918, Escher suit des cours privés d'architecture à l'École supérieure de technologie de Delft, mais il doit rapidement abandonner pour des raisons de santé ; il est d'ailleurs dispensé du service militaire en 1919. Pendant cette période difficile, il dessine énormément et commence à adopter la gravure sur bois comme support. Les premières œuvres d'Escher datent de cette époque et parmi elles figure un portrait de son père George, la plus ancienne de ses œuvres qui soit parvenue jusqu'à nous.

Aspirant à être architecte, Escher s'inscrit à l'École d'architecture et des arts décoratifs de Haarlem. Il montre à Samuel Jessurun de Mesquita, son professeur de dessin d'après nature, certaines gravures sur linoléum. Mesquita détecte immédiatement le potentiel de son élève et l'aide à réorienter ses études vers le dessin et la gravure. Il s'améliore rapidement, notamment en gravure sur bois, et crée des œuvres d'une maturité surprenante. Une grande amitié naîtra entre les deux hommes, et Escher sera bouleversé lorsque son ami sera fait prisonnier dans un camp de concentration puis exécuté. Mesquita lui apprend tout ce qu'il sait des techniques de gravure sur bois, lui offre un espace de réalisation et lui est d'un énorme soutien.

En 1921, Escher part avec sa famille sur la Côte

d'Azur et à Rome, où il dessine en détail des cactus et des oliviers et recherche des vues captivantes pour en faire des croquis depuis des points d'observation en hauteur. À cette période, il commence à faire des essais avec des sujets phares de son œuvre postérieure, que sont les images en miroir, les sphères et les formes cristallines. Les gravures sur bois qu'il réalise pour la brochure humoristique Flor de Pascua [Poinsettia], de A. P. van Stolk, en sont l'illustration. Par ailleurs, la même année, sa planche Saint François (prêchant aux oiseaux) est la première à se vendre à de nombreux exemplaires.

L'ITALIE ET L'ESPAGNE. Une fois l'école terminée, Escher part pour l'Italie en quête d'une inspiration nouvelle. Après quelques semaines à Florence, il se rend à San Gimignano, Volterra et Sienne, où sa production de dessins est conséquente. Durant le printemps 1922, il parcourt la campagne italienne et dessine des paysages, des plantes, et même des insectes. De retour chez lui en juin, il comprend vite que cet environnement n'est plus productif et il en profite pour aller en Espagne avec des amis, sur un cargo. Il visite l'Alhambra, palais maure du quatorzième siècle situé à Grenade, découvre des exemples de styles décoratifs arabes et succombe à la fascination de la division régulière du plan. Il crée alors Huit têtes, sa première gravure sur bois du genre, annonciatrice des œuvres à venir.

Son périple le ramène en Italie et il s'installe quelques mois à Sienne, dont il profite pleinement et où il travaille intensément. Escher séjourne également à Ravello, où il rencontre et tombe amoureux de sa future épouse Jetta Umiker, fille d'un industriel suisse. De retour à Sienne, il organise sa première exposition en solitaire en août 1923, une étape clé dans sa carrière artistique. Escher organise aussi sa première exposition en solitaire dans son pays natal en février 1924.

Escher se marie avec Jetta Umiker en 1924, et le couple s'installe à Rome pour fonder une famille. Preuve de la renommée croissante d'Escher, le roi Emmanuel d'Italie et Mussolini assistent au baptême de son fils George en 1926. La famille réside en Italie jusqu'en 1935, et pendant ces 11 années les sujets phares de l'art d'Escher sont Rome et la campagne italienne. Il passe souvent le printemps et l'été à voyager à travers le pays pour dessiner. C'est là qu'il réalise certains de ses paysages les plus remarquables, dont beaucoup sont dessinés depuis des angles vertigineux avec des perspectives impressionnantes.

Escher crée souvent des effets spatiaux énigmatiques en combinant des points de vue variés et parfois contraires, comme le fait d'observer vers le haut et vers le bas à la fois. L'intensité de ces effets est souvent accentuée par son traitement de la lumière, qui donne des contrastes marqués de noir et blanc. En 1925, il crée ce qui sera son premier vrai pavage : une gravure sur planche de lions, dans laquelle le sujet s'imbrique et recouvre le plan.

À Rome, Escher a une vie heureuse avec sa femme et ses enfants et connaît une longue période de productivité à la fin des années 1920. Il expose ses œuvres dans plusieurs galeries des Pays-Bas et sa renommée est telle que pas moins de cinq expositions lui sont consacrées en 1929 en Hollande et en Suisse. Au cours de cette période, ses images de paysages saisissants et ses illustrations commerciales sont qualifiées de mécaniques et « raisonnées ». Son second fils Arthur naît en décembre 1928.

Au début des années 1930, la santé d'Escher est fragile, mais il parvient à publier l'ouvrage XXIV Emblemata (1932). En 1933, il vend quelques œuvres au Rijksmuseum d'Amsterdam et en achève d'autres pour le livre The Terrible Adventures of Scholastica. Son œuvre Nonza remporte le troisième prix à l'exposition d'art contemporain de l'Art Institute of Chicago et s'inscrit comme le pre-

mier travail d'Escher acheté par un musée américain.

MÉTAMORPHOSE – Un point d'inflexion dans l'œuvre d'Escher. L'instabilité politique croissante force la famille Escher à déménager en Suisse en 1935. Escher a rapidement la nostalgie des paysages saisissants du sud de l'Italie. En 1936, Maurits et Jetta font donc une croisière le long des côtes d'Italie et de France jusqu'en Espagne, où ils visitent à nouveau l'Alhambra. Le voyage commence le 26 avril 1936 et, les deux mois suivants, de nombreux croquis voient le jour et serviront de base de travail pour la suite.

Cette phase dénote un point d'inflexion dans le travail d'Escher, car il passe des paysages à « l'imagerie mentale », au graphisme et aux mosaïques. Le principe de « métamorphose », selon lequel une forme ou un objet se transforme en autre chose de totalement différent, est de fait l'un des thèmes préférés d'Escher depuis les années 1920. Après la seconde analyse des mosaïques sophistiquées de l'Alhambra, la fascination d'Escher pour l'ordre, la symétrie et les pavages est absolue ; pour lui, il s'agit de « la source d'inspiration la plus riche jamais découverte ».

À la fin des années 1930, Escher développe la « division régulière du plan », ces fameux « pavages » qui sont des agencements de formes fermées recouvrant entièrement le plan sans se chevaucher et sans laisser d'espaces vides. Escher étudie notamment la façon dont les formes interagissent entre elles et il s'amuse à remplacer les motifs abstraits des mosaïques maures par des figures identifiables. Il fait de nombreux essais avec des motifs aussi variés que des haltérophiles, des chameaux, des écureuils et des oiseaux. En 1937, il applique ce concept à sa célèbre œuvre Métamorphose, qui présente un édifice se transformant en figure humaine.

Au milieu de l'année 1937, la famille Escher s'installe à Bruxelles et, en octobre, l'artiste montre certains de ses pavages de remplissage du plan à son frère Beer, professeur de géologie. Beer remarque la similitude entre les gravures sur bois de son frère et la cristallographie et lui envoie une série d'articles sur le sujet. L'un d'eux est signé par le professeur George Pólya, qui explique sous forme de croquis les 17 motifs de papier peint graphiquement possibles et avance qu'un artiste peut s'en servir comme base. Escher est subjugué : il réalise aussitôt Développement I et l'envoie au professeur.

Au long de l'année 1938, Escher poursuit ses essais « cristallographiques », l'un des plus connus étant Jour et nuit. En 1939, il achève Métamorphose 2, son œuvre la plus grande, qui mesure 3,9 mètres sur 19 cm et illustre 10 transformations. Un essai ultérieur en mosaïque représente un poisson qui nage gravé sur une sphère en bois de hêtre, que l'artiste portera sur lui comme talisman jusqu'à la fin de sa vie.

En 1941, l'invasion allemande de la Belgique pousse la famille Escher à revenir s'installer dans le pays natal de l'artiste, à Baarn. Escher apprend que son maître Samuel de Mesquita, Juif, a été capturé et tué par les nazis. Cette nouvelle l'affecte profondément ; lors du transfert de l'œuvre de Mesquita au musée Stedelijk d'Amsterdam, il garde en secret l'un de ses dessins, qui représente la botte d'un Allemand. Au terme de la guerre, il participe à une exposition d'artistes s'étant opposés au régime nazi. L'événement est suivi de plusieurs commandes, dont 400 copies de l'une de ses créations pour des écoles. Le fameux tableau Reptiles (1943), réalisé à cette période, illustre un petit crocodile sortant d'un pavage et passant sur des objets. Tous ces pavages portent un numéro, le total atteignant 137 à sa mort.

La guerre terminée, Escher s'intéresse à une nouvelle technique de gravure, le mezzotinto. L'une de ses plus célèbres compositions est Goutte de rosée (1948), qui illustre bien les tracés déli-

cats propres à la technique. En 1949, lors d'une exposition à Rotterdam avec deux autres artistes, Escher présente ses œuvres et en profite pour expliquer ses techniques. Les ventes sont bonnes, notamment pour l'immense Métamorphose II.

RENOMMÉE CROISSANTE. Sa popularité augmente tellement qu'en 1949–1950, il reçoit des commandes pour des services plus inhabituels : par exemple, il crée une tapisserie pour un tisserand et l'entreprise Philips (Pays-Bas) lui confie la décoration d'un plafond pour son 60e anniversaire. Aux États-Unis toutefois, seuls les collectionneurs spécialisés connaissent son travail. En 1951, Escher réalise sa célèbre lithographie La maison aux escaliers.

À la parution en 1951 de deux articles dans les magazines Time et Life, il gagne encore en reconnaissance sur le territoire américain et dans le reste du monde. Grâce à cette publicité, la demande augmente pour son travail et ses services de conférencier, et ses visions convainquent les sphères tant artistiques que scientifiques. En 1954 se tient sa première grande exposition sur le sol américain, à la Whyte Gallery, à Washington D.C, preuve indéniable de son succès croissant. Sans s'y attendre, Escher devient donc une célébrité, et sa surprise n'est pas moindre lorsque la reine des Pays-Bas lui décerne la décoration de Commandeur de l'ordre d'Oranje-Nassau.

Une nouvelle tendance s'impose dans son travail de 1956 à 1958, comme le montrent De plus en plus petit (1956), Tourbillons (1957), puis Serpents. Il recherche une technique de représentation de l'infini dans les limites d'un tableau. Avant 1958, il dessine des objets rapetissant vers le centre ; à partir de cette date, la contraction se fait vers les bords. Ce changement se doit en partie à un article du mathématicien canadien Coxeter d'Ottawa, qui expose un système de réduction de l'échelle d'un motif de remplissage du plan proportionnellement à sa distance par rapport au centre du cercle.

En 1959, Escher a l'occasion de donner une conférence sur la symétrie devant un groupe international de cristallographes en Angleterre, ce qui rapproche plus que jamais son travail de l'univers des mathématiques. Des amis lui passent un article de Roger Primrose sur les « objets impossibles » qui fait référence aux premières créations d'Escher. Cette mention lui inspire Ascendant et descendant (1960), fondé sur l'escalier sans fin décrit dans l'article.

En 1960, Escher publie son premier ouvrage, intitulé Grafiek en Tekeningen, dans lequel il présente 76 de ses compositions. Le livre attire l'attention de cristallographes du monde entier et Escher donne des conférences dans de nombreux pays, dont l'Angleterre, la Russie, le Canada et les États-Unis. Celle qui se tient en août, lors de la convention de cristallographes à Cambridge, est un moment phare ; 1960 est une année de réussite, tant sur le plan artistique que commercial.

Le travail périodique (mosaïque) d'Escher gagne en popularité à la fin des années 1950 et aux débuts des années 1960, et plusieurs ouvrages et d'autres conférences s'ensuivent. Malheureusement, Escher tombe malade en 1964 et ne peut honorer ses engagements de conférencier en Amérique du Nord. Il remporte néanmoins le prix culturel de la ville de Hilversum et l'étude « Symmetry Aspects of M.C. Escher's Periodic Drawings », de la cristallographe Caroline H. MacGillavry, est publiée en août 1965. En 1968 ont lieu des expositions à Washington, D.C. à la Mickelson Gallery et à La Haye, au Gemeentemuseum. Escher achève Métamorphose III pour le bureau de poste de La Haye, présenté au public le 20 février 1969.

En 1970, la santé d'Escher se dégrade encore et sa femme, qui n'avait jamais été heureuse à Baarn, repart définitivement en Suisse. Escher poursuit ses dessins et ses gravures sur bois et il

vit suffisamment longtemps pour voir un ouvrage complet sur sa vie publié en néerlandais, mais aussi en anglais (Le monde de M.C. Escher).

Escher s'éteint le 27 mars 1972 à l'âge de 73 ans, dans une résidence pour anciens artistes. Au cours de sa vie, il a réalisé 448 lithographies et gravures sur bois, et plus de 2 000 dessins et croquis. Il a joué avec l'architecture, la perspective et les espaces impossibles. Son œuvre continue de fasciner des millions de personnes à travers le monde par sa fraîcheur, son originalité et son interprétation de la réalité comme merveilleuse, intelligible et captivante.

BIOGRAFIE

Der niederländische Künstler Maurits Cornelis Escher (1898-1972) ist einer der berühmtesten Grafikkünstler der Welt und wird oft als "Vater" moderner Mosaiken, d.h. gleichmäßiger Flächenteilungen, betrachtet. Von Millionen von Menschen bewundert, hat er sich vor allem durch seine so genannten "unmöglichen Objekte" und Transformationsdrucke einen Namen gemacht, darunter Treppauf Treppab, Relativität, Metamorphose I, II und III, Himmel & Wasser und Reptilien. M.C. Escher war ein Meister der Linoleum- und Holzschnitte und schuf außerdem während seiner Italienreisen beeindruckende Landschaftsdarstellungen.

Escher arbeitete als Zeichner, Buchillustrator, Wandteppich-Designer und Wandmaler - aber in erster Linie war er Grafiker. Sein Genie zeigte sich in der außergewöhnlichen Fähigkeit, in seiner Kunst mathematische Ideen zu verarbeiten, wie die Logik des Raumes, gleichmäßige Flächenteilungen, Paradoxe und unmögliche Objekte, wobei er oftmals gegensätzliche Konzepte wie Ordnung und Unordnung, Höhe und Tiefe, Nähe und Entfernung u.ä. ausglich.

Im Laufe seines Lebens beschäftigte er sich zunehmend damit, Flächen mit Bildern zu füllen, die sich nicht überschnitten und keine Zwischenräume ließen. Mit 68 bemerkte er: "Eine Fläche zu füllen ist zur regelrechten Manie geworden, nach der ich süchtig geworden bin und von der ich mich manchmal nur schwer losreißen kann." Dies ist seine Lebensgeschichte.

DIE FRÜHEN JAHRE. Am 17. Juni 1898 wurde Escher in Leeuwarden, Holland, geboren und von seinem Vater George Escher, einem Bauingenieur, und dessen zweiter Frau Sarah, Tochter eines Regierungsministers, großgezogen. Er war der jüngste von vier Söhnen. Die Familie lebte in einem vornehmen Haus, "Princessehof" genannt, das später ein Museum wurde und Eschers Arbeiten ausstellte.

Maritz, von seinen Eltern Mauk genannt, verbrachte seine Jugend (1903-1918) in Arnheim, wo er die Grundschule und weiterführende Schule besuchte. In letzterer erhielt Escher seinen ersten Malunterricht von F.W. van der Haagen, der bemerkte, dass er gerne mit Stift und Tinte zeichnete, und ihm beibrachte, wie man Linoleumschnitte erstellte. Escher schickte einige davon an Ronald Holtz, dem damals berühmtesten Grafikkünstler. Dieser zeigte sich beeindruckt und schlug Escher vor, Holz als Material zu verwenden.

Vom Zeichnen abgesehen, waren Eschers Noten schlecht, und er entwickelte ein großes Interesse an Drucktechniken und grafischen Arbeiten im Allgemeinen. Escher fiel in den Fächern Geschichte, Staatliche Organisationen, Volkswirtschaft und Buchhaltung durch seine Abschlussprüfungen und erhielt nie einen offiziellen Abschluss. Holtz schlug ihm daher vor, Architektur zu studieren.

1918 begann Escher, privaten Unterricht in Architektur an der Higher Technology School in Delft zu nehmen, musste aber aus gesundheitlichen Gründen bald abbrechen. 1919 wurde er vom Militärdienst abgelehnt. In dieser schwierigen Zeit zeichnete Escher viel; außerdem begann er mit Holzschnitten zu arbeiten. In jener Zeit entstanden seine ersten Arbeiten, so auch sein erstes noch erhaltenes Werk, ein Porträt seines Vaters George.

Um Architekt zu werden, besuchte er die Schule für Architektur und dekorative Künste in Haarlem. Er zeigte seinem Zeichenlehrer Samuel Jessurum de Mesquita einige seiner Linoleumschnitte. Dieser erkannte sofort das Potential seines Schülers und half ihm, sich dem Studium der Malerei und Grafik zuzuwenden. Eschers Fertigkeiten entwickelten sich schnell, vor allem bei den Holzschnitten, und er schuf Werke von erstaunlicher Reife. Er und Mesquita wurden lebenslange Freunde. Escher war tief erschüttert,

als sein Freund in einem Konzentrationslager umgebracht wurde. Mesquita hatte ihm sein gesamtes Wissen über die Drucktechnik von Holzschnitten vermittelt, ihm Raum zur Entwicklung ermöglicht und ihn stets unterstützt.

1921 besuchte er mit seiner Familie die Französische Riviera und Rom, wo er Kakteen, Olivenbäume und faszinierende Ausblicke von hoch gelegenen Aussichtspunkten malte. In dieser Zeit begann M.C. Escher, mit Motiven zu experimentieren, die in seinen späteren Arbeiten eine zentrale Rolle spielen sollten: Spiegelbilder, Linsenformen und Kugeln. Dies veranschaulichen die Holzschnitte, die er für die Broschüre Flor de Pascua [Osterblume] erstellte. Im selben Jahr entstand mit St. Francis (Die Vogelpredigt) der erste Druck, der sich in einer hohen Auflage verkaufte.

ITALIEN UND SPANIEN. Nach seinem Studium suchte Escher in Italien nach neuer Inspiration. Nach nur zwei Wochen in Florenz reiste er nach San Gimignano, Volterra und Siena, wo er viel zeichnete. Den Frühling 1922 verbrachte er auf dem Land, wo er Landschaften, Pflanzen und sogar Insekten zeichnete. Als er im Juni nach Hause zurückkehrte, bemerkte er schnell, dass dies keine produktive Umgebung mehr für seine Arbeit war, und reiste mit Freunden auf einem Frachtschiff nach Spanien. Er besuchte die Alhambra, einen maurischen Palast in Granada, sah Beispiele dekorativer arabischer Bauweise, war fasziniert von der gleichmäßigen Flächenteilung und schuf Acht Köpfe, seinen ersten Holzschnitt dieser Art und ein Hinweis darauf, was noch kommen sollte.

Seine Reise führte ihn zurück nach Italien, wo er sich einige Monate in Siena aufhielt und vergnügte, aber auch hart arbeitete. Escher besuchte auch Ravello, wo er sich in seine zukünftige Frau Jetta Umiker verliebte, die Tochter eines Schweizer Industriellen. Nachdem er nach Siena zurückgekehrt war, fand im August 1923 seine erste eigene Ausstellung statt – ein Meilenstein seiner künstlerischen Karriere. Die erste Solo-Ausstellung in seinem Heimatland Holland fand im Februar 1924 statt.

Escher heiratete Jetta Umiker 1924. Das Paar ließ sich in Rom nieder, um eine Familie zu gründen. Eschers wachsender Ruhm zeigte sich darin, dass König Emmanuel von Italien und Mussolini 1926 der Taufe seines Sohnes George beiwohnten. Die Familie blieb bis 1935 in Italien. Während dieser elf Jahre waren Rom und das ländliche Italien die Hauptthemen in Eschers Kunst. Im Frühling und im Sommer reiste er oft durch das Land, um zu zeichnen, und schuf einige seiner einprägsamsten Landschaftswerke, meist von schwindelerregenden Höhen und aus verblüffenden Perspektiven gezeichnet.

Escher erzeugte oft geheimnisvolle räumliche Effekte, indem er mehrere, manchmal sich widersprechende Blickwinkel kombinierte, z.B. gleichzeitiges Hinauf- und Hinabblicken. Diese Effekte gestaltete er mit Hilfe von Licht und starken Schwarz-Weiß-Kontrasten oft noch dramatischer. 1925 erstellte er sein erstes Mosaik, einen Handdruck mit Löwen, die ineinander verschachtelt waren und die ganze Fläche ausfüllten.

Glücklich mit Frau und Kind in Rom, waren die späten 20er Jahre eine produktive Zeit für Escher. Er stellte seine Werke in Holland aus und war 1929 so berühmt, dass er in diesem Jahr fünf Ausstellungen in Holland und in der Schweiz veranstaltete. In dieser Zeit wurden seine Landschaftsbilder und kommerziellen Illustrationen erstmals mit den Worten "mechanisch" und "logisch aufgebaut" beschrieben. Sein zweiter Sohn Arthur wurde im Dezember 1928 geboren.

In den frühen 30er Jahren war Eschers Gesundheitszustand zwar instabil, aber es gelang ihm, Emblemata (1932) zu veröffentlichen. 1933

verkaufte er einige Drucke an das Rijksmuseum in Amsterdam und stellte andere für das Buch The Terrible Adventures of Scholastica fertig. Sein Druck Nonza gewann den dritten Platz bei der Ausstellung zeitgenössischer Drucke im Kunstinstitut Chicago und war das erste Werk Eschers, das von einem amerikanischen Museum gekauft wurde.

METAMORPHOSE – Ein Wendepunkt in Eschers Werk. Wachsende politische Unruhen zwangen die Familie, 1935 in die Schweiz zu ziehen. Schon bald vermisste Escher die Landschaften Süditaliens, weshalb er 1936 mit Jetta eine Reise entlang der Küsten Italiens und Frankreichs nach Spanien unternahm. Dort besuchten sie diesmal gemeinsam die Alhambra. Die Reise begann am 26. April 1936, und in den folgenden zwei Monaten erstellte Escher zahlreiche Skizzen, die die Grundlagen für künftige Werke bildeten.

Sie bedeuteten einen Wendepunkt in Eschers Werk: Er wandte sich von Landschaften ab und "geistigen Bilderwelten", grafischen Arbeiten und Kacheln zu. Die Idee der "Metamorphose", eine Form oder ein Objekt, das sich in etwas komplett Anderes verwandelt, war seit den 20er Jahren eines von Eschers bevorzugten Themen. Nachdem er zum wiederholten Male die kunstvollen Kachelarbeiten studiert hatte, war Escher fasziniert von Ordnung, Symmetrie und Mosaiken. In seinen eigenen Worten war dies "die reichste Quelle der Inspiration, die ich je angezapft habe".

In den späten 30er Jahren entwickelte Escher "die gleichmäßige Flächenteilung", so genannte Mosaiken: Anordnungen, die eine Fläche komplett bedecken, ohne sich zu überschneiden oder Zwischenräume frei zu lassen. Escher interessierte sich besonders für die Art und Weise, in der die Formen miteinander interagierten, und er verwandelte die abstrakten Muster maurischer Kacheln in erkennbare Figuren. Er experimentierte mit zahlreichen verschiedenen Motiven, wie Gewichthebern, Kamelen, Eichhörnchen und Vögeln. 1937 wandte er dieses Konzept auf seinen bekannten Metamorphose-Druck an, der einen Häuserblock zeigte, der sich in eine kleine menschliche Figur verwandelte.

Mitte 1937 ließ sich die Familie Escher in Brüssel nieder, und im Oktober zeigte Escher einige seiner flächenfüllenden Mosaiken seinem Bruder Beer, einem Professor für Geologie. Beer lenkte Eschers Aufmerksamkeit auf die Ähnlichkeit seiner Holzschnitte mit bestimmten kristallographischen Strukturen und sandte seinem Bruder eine Liste mit Artikeln zu diesem Thema. Einer stammte von Professor George Pólya und skizzierte 17 mögliche Tapetendesigns. Er wies darauf hin, dass ein Künstler von diesem Wissen Gebrauch machen könnte. Escher war erstaunt, schnitzte sofort Entwicklung 1 und schickte es ihm.

Escher arbeitete das ganze Jahr 1938 hindurch an seinen "kristallographischen" Experimenten; einer seiner berühmtesten Drucke, Tag und Nacht, entstand. 1939 vollendete er Metamorphose II, seinen größten Druck, der 3,9 Meter mal 19 cm maß. Dieser hoch gelobte Druck zeigte 10 Metamorphosen. Ein weiteres Experiment mit Kacheln war ein schwimmender Fisch, in eine Kugel aus Buchenholz geschnitzt, die er sein Leben lang als Talisman bei sich trug.

Die deutsche Invasion Belgiens im Jahre 1941 veranlasste die Familie Escher, zurück nach Baarn in Holland zu ziehen. Escher erfuhr, dass sein ehemaliger Lehrer Samuel de Mesquita, ein Jude, von den Nazis verschleppt und umgebracht worden war. Als Mesquitas Arbeiten in das Stedelijk Museum in Amsterdam überführt wurden, behielt Escher heimlich eines der Werke, den Abdruck eines deutschen Stiefels, bei sich. Nach dem Krieg nahm er an einer Ausstellung von Künstlern teil, die vom Naziregime nicht unterstützt worden waren. Dies verhalf ihm zu einigen Aufträgen, unter

anderem mit 400 Kopien eines seiner Werke, die für den Schulunterricht verwendet werden sollten.

Das in dieser Periode entstandene berühmte Bild Reptilien (1943) stellt ein winziges Krokodil dar, das aus einem Mosaik heraus über mehrere Bücher kriecht. Er nummerierte all seine Mosaiken; bis zu seinem Tode waren es 137.

Am Ende des Krieges interessierte sich Escher für eine neue Drucktechnik: Mezzotint. Eines der schönsten Beispiele hierfür ist Tautropfen (1948), das die raffinierten und feinen Linien dieser Technik demonstriert. Bei einer Ausstellung mit zwei weiteren Künstlern in Rotterdam 1949 präsentierte Escher nicht nur seine Werke, sondern auch seine Techniken. Dies führte zu einem guten Verkauf seiner Drucke, unter anderem der riesigen Metamorphose II.

WACHSENDER RUHM. Sein Ruhm wuchs in einem solchen Maße, dass er 1949-1950 ungewöhnlichere Aufträge erhielt: Er entwarf einen Dekorationsstoff für einen Weber, und Philip von Holland beauftragte ihn, eine Deckendekoration für sein 60. Jubiläum zu entwerfen. In den USA waren seine Arbeiten allerdings nur spezialisierten Sammlern von Drucken bekannt. 1951 schuf Escher die berühmte Lithografie Haus der Treppen.

Er gewann Anerkennung in den USA und weltweit, als 1951 zwei Artikel in den Magazinen Time und Life erschienen. Mit zunehmendem Bekanntheitsgrad wuchs der Verkauf seiner Arbeiten, und er war plötzlich auch als Dozent gefragt. 1954 veranstaltete er seine erste größere amerikanische Ausstellung in der Whyte Gallery, Washington D.C. – ein bedeutsames Ereignis für seinen wachsenden Ruhm und Erfolg. Escher war wider Erwarten zu einer Berühmtheit geworden. Er war ziemlich überrascht, als ihn die Königin von Holland mit dem Ritterorden von Oranje Nassau auszeichnete.

1965-1958 zeichnete sich im Werk Eschers eine neue Tendenz ab, die man in Kleiner und Kleiner (1956), in Whirlpools (1957) und in Schlangen erkennt. Er suchte nach einer Technik, mit der er Unendlichkeit innerhalb der Grenzen eines Druckes ausdrücken konnte. Seine Arbeiten vor 1958 zeigten Objekte, die zur Mitte des Druckes hin schrumpften; nach 1958 schrumpften die Objekte solcher Drucke in Richtung der Bildecken. Diese Veränderung lässt sich teilweise auf einen Artikel des kanadischen Mathematikers Coxeter aus Ottawa zurückführen, den er gelesen hatte. Dort wird ein System beschrieben, nach dem die Größe des flächendeckenden Motivs proportional zu seinem Abstand vom Mittelpunkt eines Kreises verringert wird.

1959 bekam Escher die Möglichkeit, in England vor einer internationalen Gruppe von Kristallographen einen Vortrag über Symmetrie zu halten – hier kam seine Arbeit den Mathematikern näher als jemals zuvor. Eschers Freunde gaben ihm einen Artikel von Roger Primrose über "unmögliche Objekte", in dem auch Eschers frühes Werk erwähnt wird. Dies inspirierte ihn zu seinem berühmten Werk, Treppauf Treppab (1960), das auf der im Artikel beschriebenen endlosen Treppe basiert.

1960 veröffentlichte er sein erstes Buch, Grafik en Tekeningen, in dem er 76 seiner Werke erläuterte. Das Buch zog die Aufmerksamkeit von Kristallographen aus aller Welt auf sich, und Escher hielt in vielen Ländern Vorträge, unter anderem in England, Russland, Kanada und den USA. Ein Höhepunkt waren seine Vorlesungen beim Kristallographen-Kongress in Cambridge (England) im August 1960. Es war ein sehr erfolgreiches Jahr – sowohl aus künstlerischer als auch aus kommerzieller Sicht.

In den späten 50ern und frühen 60ern wurden Eschers Kachelarbeiten sehr populär, wodurch mehrere Bücher und noch mehr Vorträge entstanden. 1964 wurde Escher allerdings krank und

konnte seinen Pflichten als Dozent in Nordamerika nicht nachkommen. Im März 1965 erhielt er den Kulturpreis der Stadt Hilversum. Im August 1965 wurde Symmetry Aspects of M.C. Escher's Periodic Drawings der Kristallographin Caroline H. MacGillavry veröffentlicht. 1968 stellte er in der Mickelson Gallery in Washington D.C. und im Gemeentemuseum in Den Haag aus. Escher arbeitete unterdessen weiter an dem Entwurf von Metamorphose III für das Postamt von Den Haag, der am 20. Februar 1969 enthüllt wurde.

1970 war sein Gesundheitszustand sehr schlecht, und seine Frau, die sich in Baarn nie wohl gefühlt hatte, zog für immer zurück in die Schweiz. Escher setzte seine Arbeit an Zeichnungen und Holzschnitten fort. Noch zu seinen Lebzeiten erschien seine Biografie nicht nur auf Niederländisch, sondern auch auf Englisch mit dem Titel The World of M.C. Escher.

Escher starb am 27. März im Alter von 73 Jahren in einem Heim für ältere Künstler. Er hat in seinem Leben 448 Lithografien, Holzschnitte und Holzgravuren sowie über 2000 Zeichnungen und Skizzen geschaffen. Er experimentierte mit Architektur, Perspektive und unmöglichen Räumen. Seine frische, fantasiereiche Kunst, die die Realität als wunderbar, begreiflich und faszinierend beschreibt, beeindruckt bis heute Millionen von Menschen in aller Welt.

EARLY PRINTS
PREMIÈRES GRAVURES
FRÜHE BLÄTTER

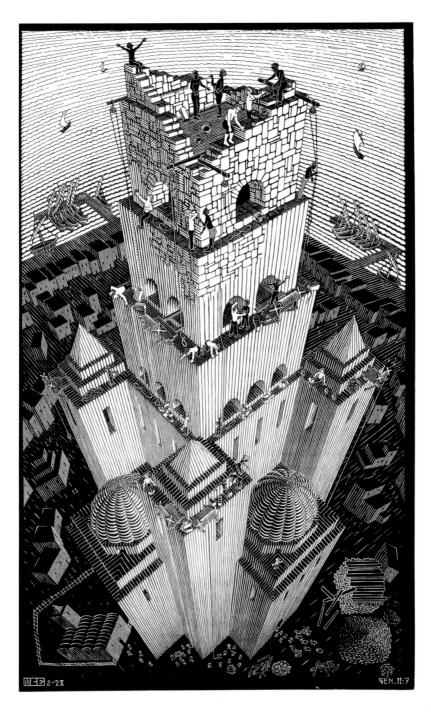

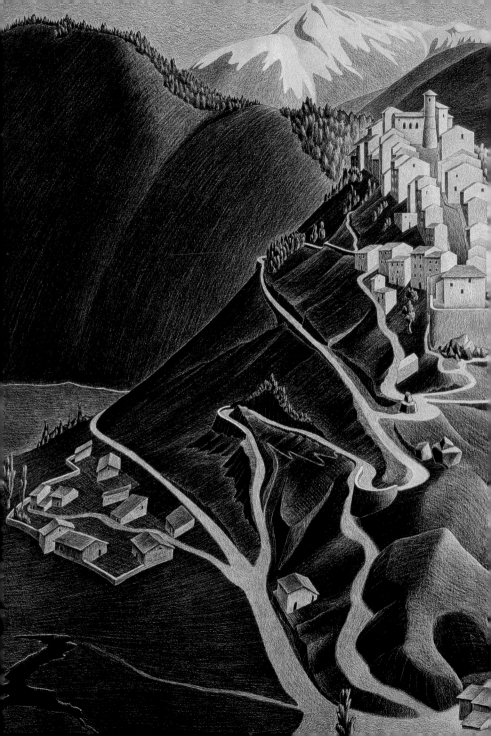

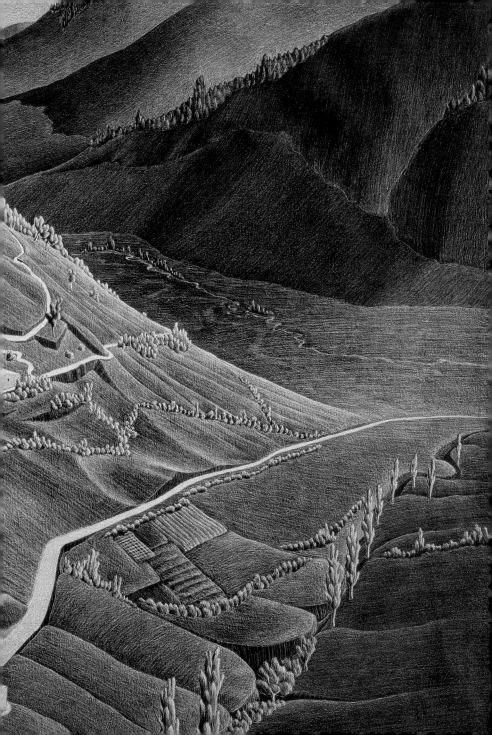

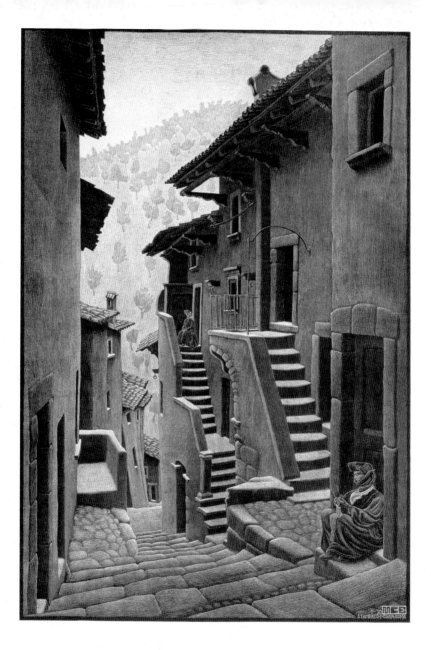

36 Street in Scanno, Abruzzi.
 Rue à Scanno, Abruzzes.
 Straße in Scanno, Abruzzen.

37 Castrovalva, [Abruzzi].
 Castrovalva, [Abruzzes].
 Castrovalva, [Abruzzen].

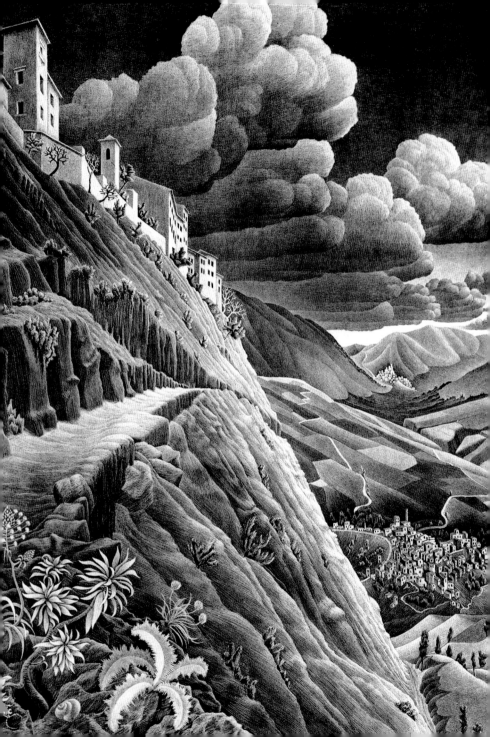

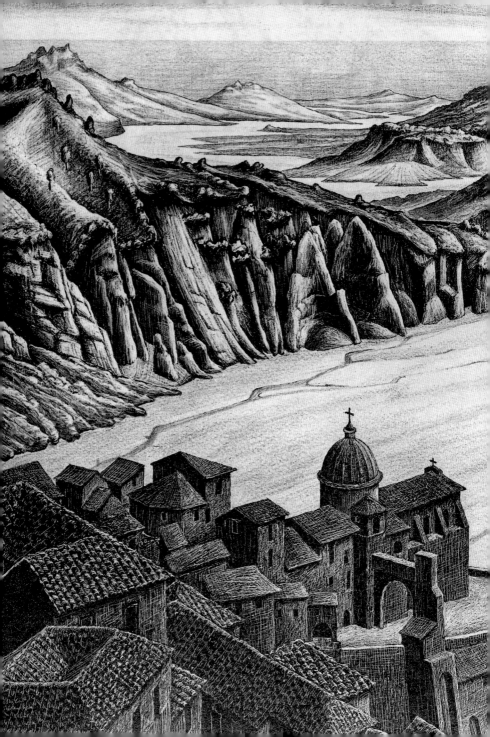

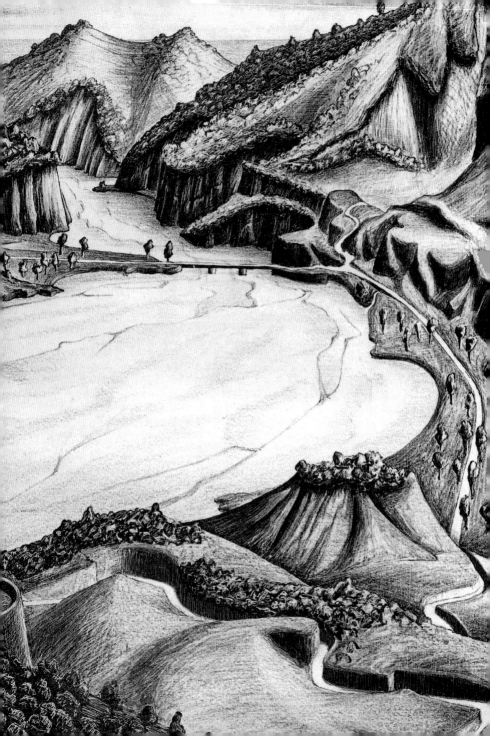

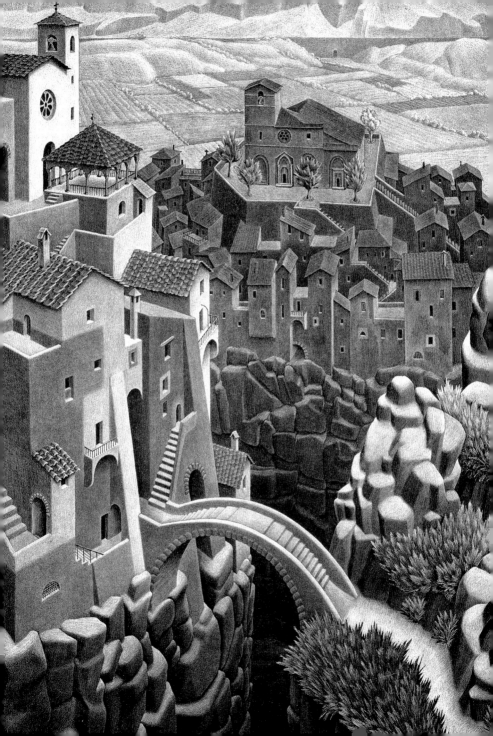

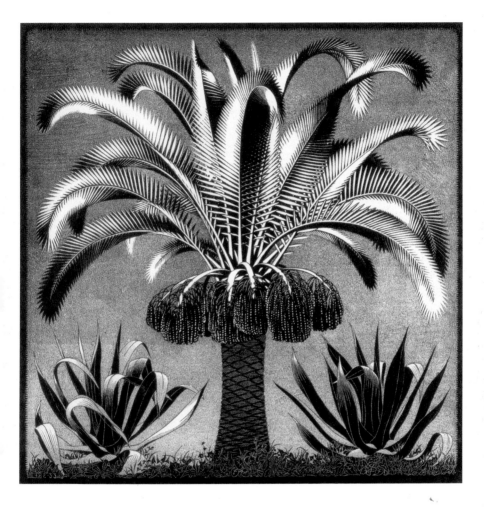

38 | 39 Fiumara (of Stilo), Calabria. 40 The Bridge. 41 Palm.
 Fiumara (de Stilo), Calabre. Le pont. Palmier.
 Fiumara (Stilo), Kalabrien. Die Brücke. Palme.

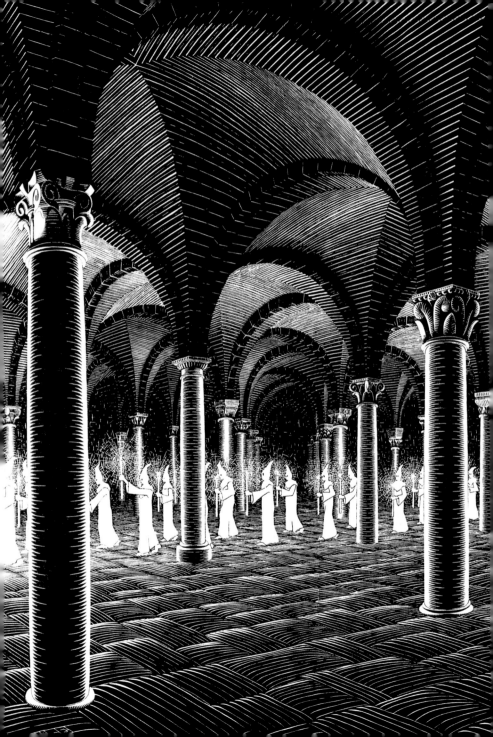

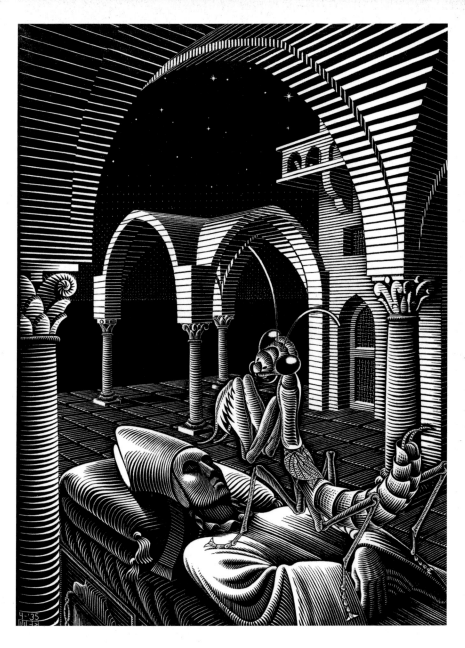

42 Procession in Crypt.
 Procession dans une crypte.
 Prozession in Krypta.

43 Dream (Mantis Religiosa).
 Rêve (Mante religieuse).
 Traum (Mantis Religiosa).

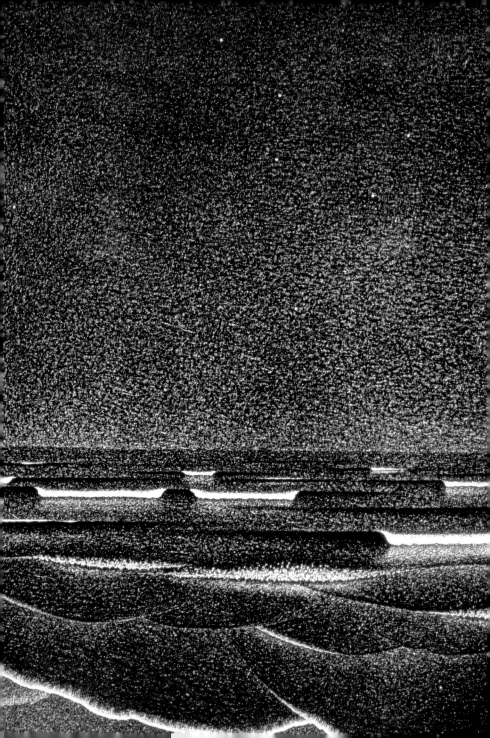

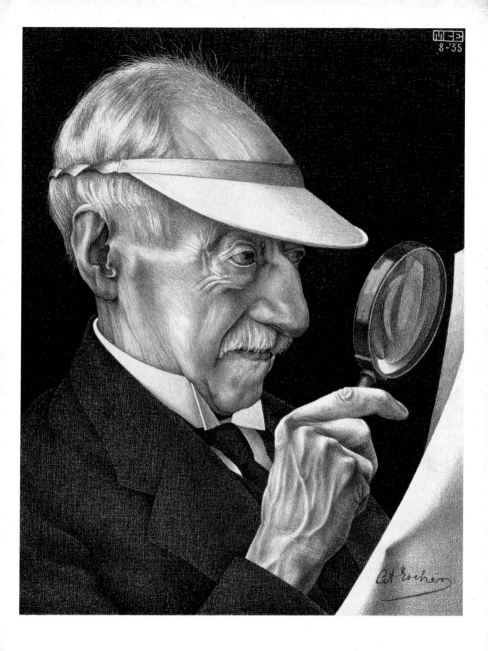

44 Phosphorescent Sea. 45 Portrait of G.A. Escher.
 La mer phosphorescente. Portrait de G.A. Escher.
 Phosphoreszierendes Meer. Porträt von G.A. Escher.

REGULAR DIVISION OF A PLANE
REMPLISSAGE RÉGULIER DE SURFACE
REGELMÄSSIGE FLÄCHENAUFTEILUNG

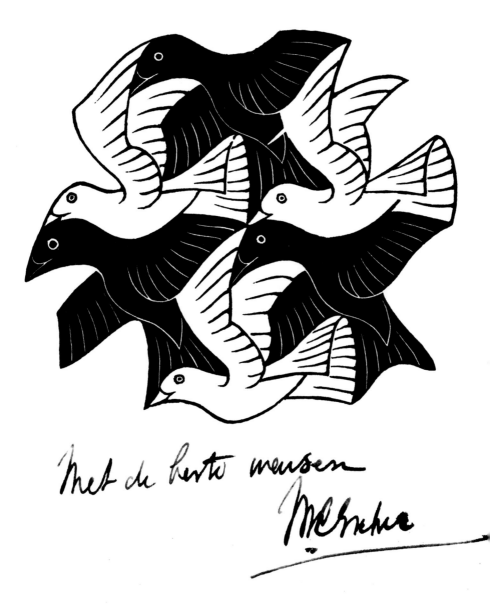

Met de beste wensen

M.C. Escher

[Plane-filling Motif with Birds].
[Remplissage du plan, motif avec des oiseaux].
[Flächendeckendes Motiv mit Vögeln].

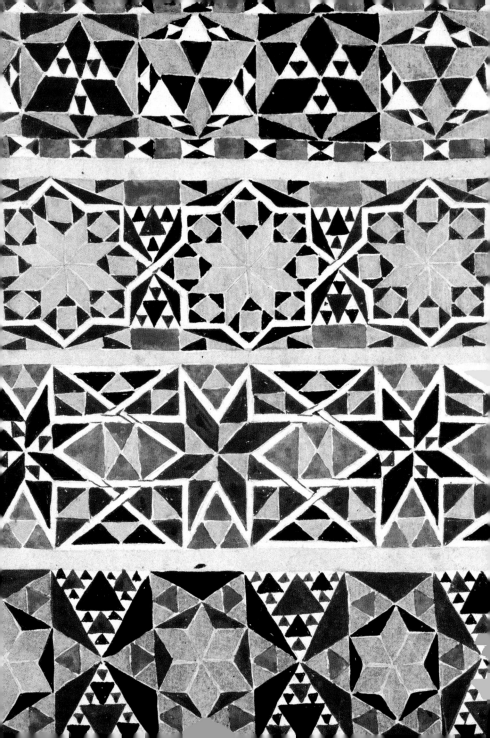

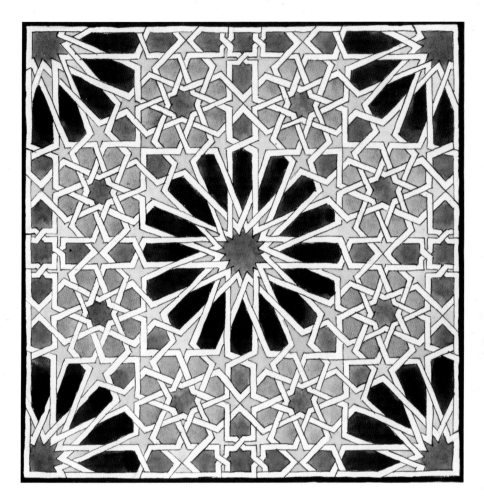

48 Escher's studies of designs on the pulpit of the Ravello cathedral.
Études de croquis d'Escher sur la chaire de la cathédrale de Ravello.
Eschers Designstudien der Kanzel der Ravello Kathedrale.

49 Mural mosaic in the Alhambra.
Mosaïque murale à l'Alhambra.
Mosaikwand in der Alhambra.

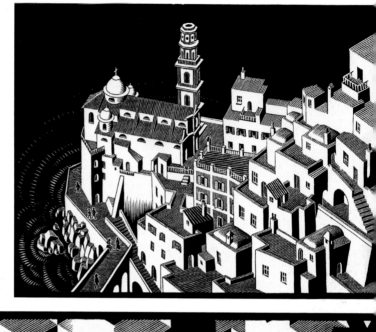

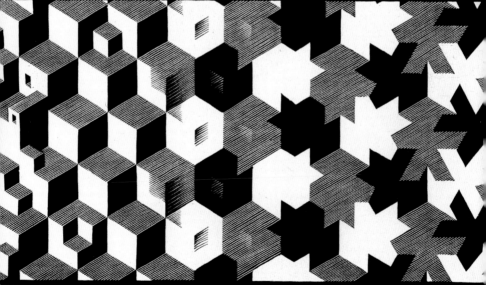

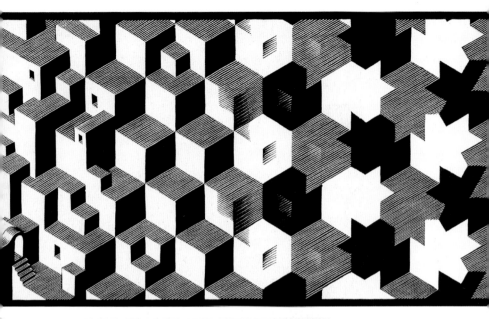

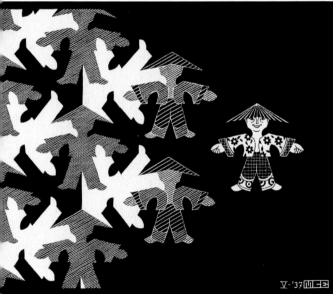

Metamorphosis [I].
Métamorphose [I].
Metamorphose [I].

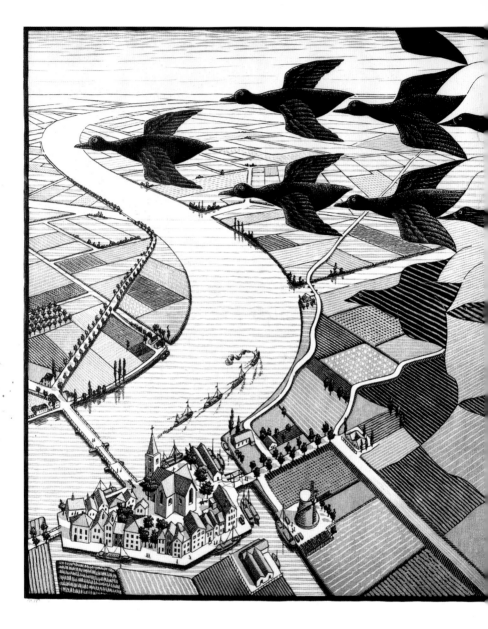

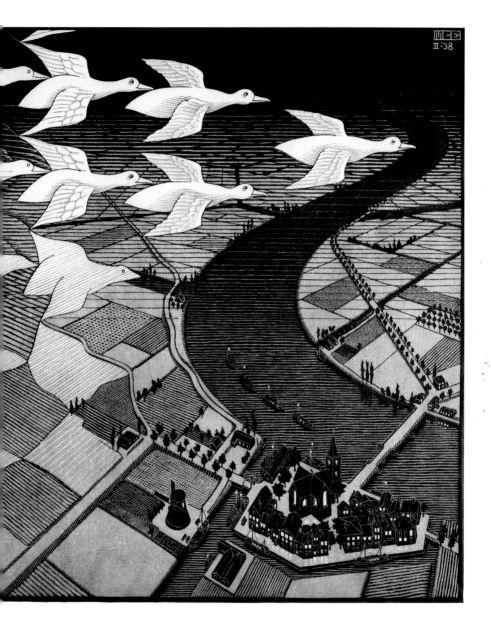

Day and Night.
Jour et nuit.
Tag und Nacht.

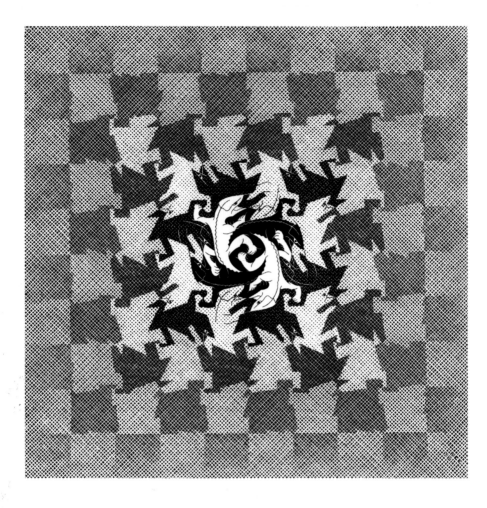

54 Development I.
 Développement I.
 Entwicklung I.

55 Cycle.
 Cycle.
 Zyklus.

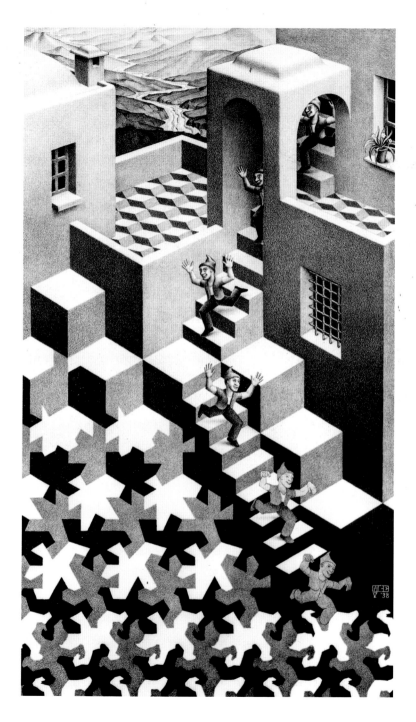

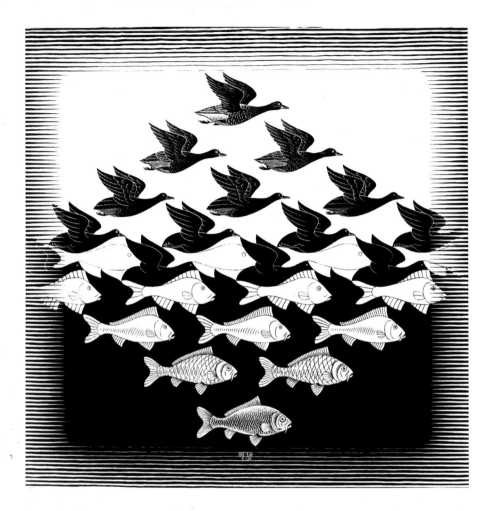

56 Sky and Water I.
Ciel et eau I.
Himmel und Wasser I.

57 Sky and Water II.
Ciel et eau II.
Himmel und Wasser II.

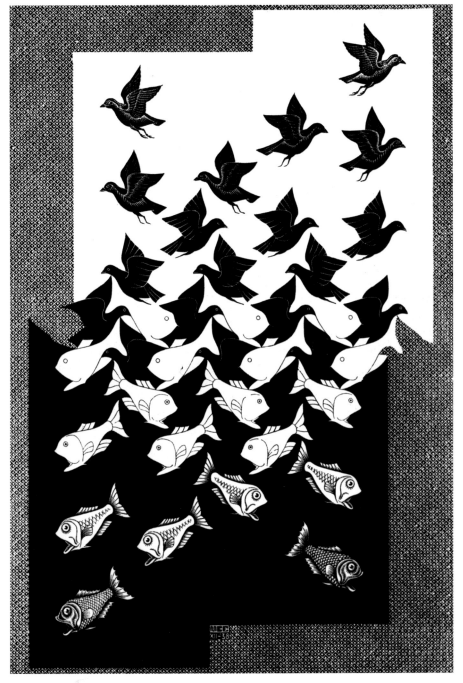

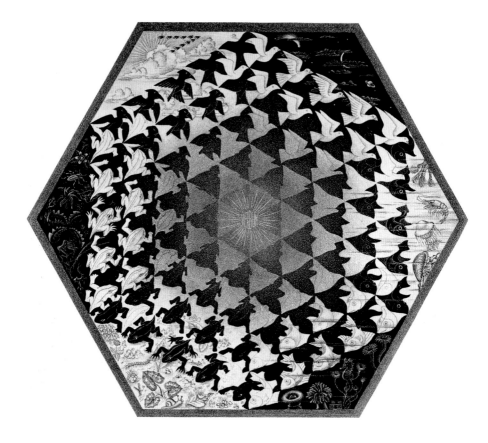

Verbum (Earth, Sky and Water).
Verbum (Terre, ciel et eau).
Verbum (Erde, Himmel und Wasser).

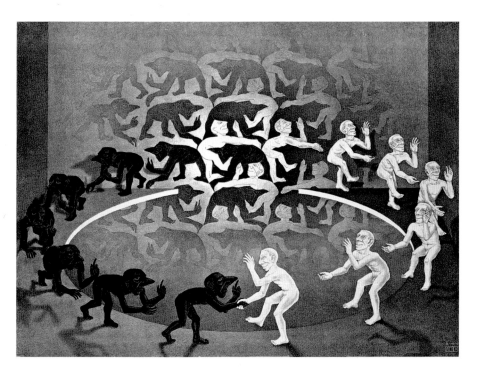

Encounter.
Rencontre.
Begegnung.

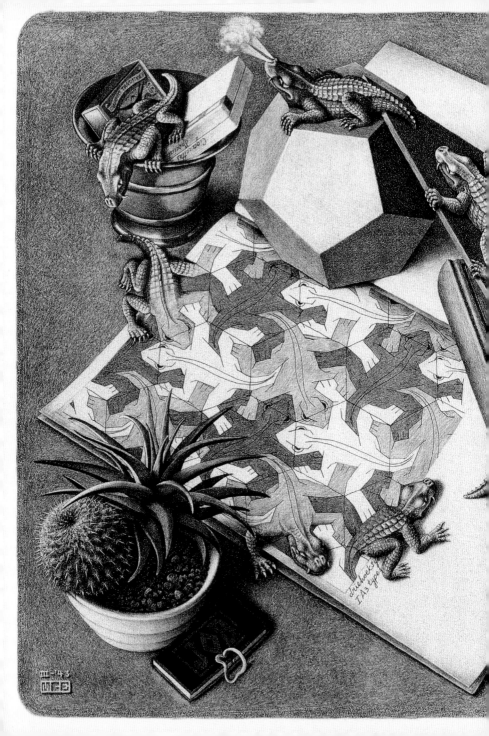

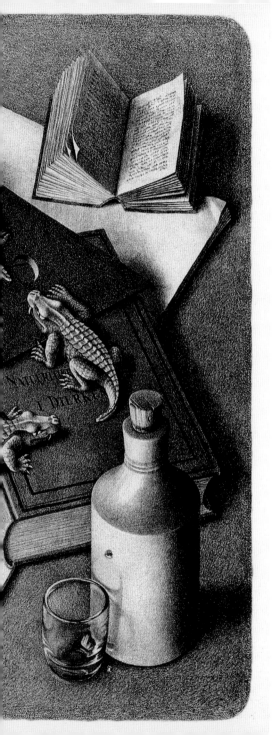

Reptiles.
Reptiles.
Reptilien.

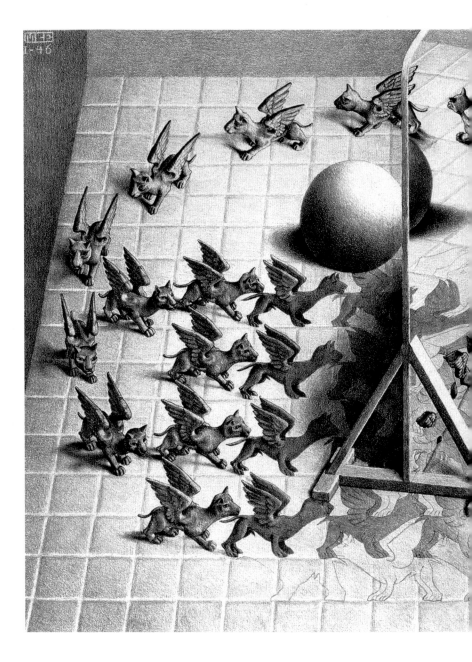

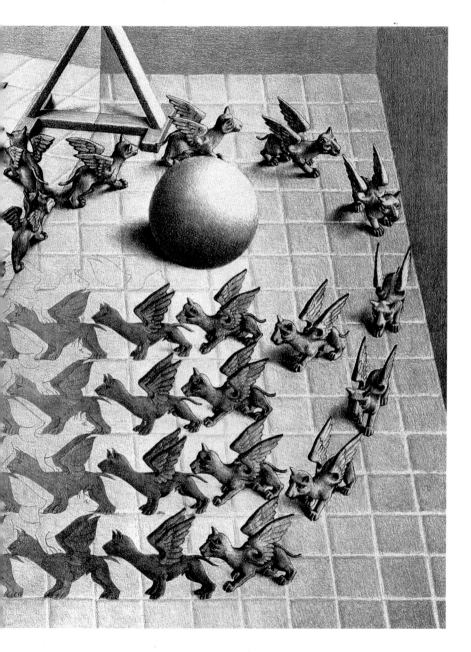

Magic Mirror.
Miroir magique.
Der Zauberspiegel.

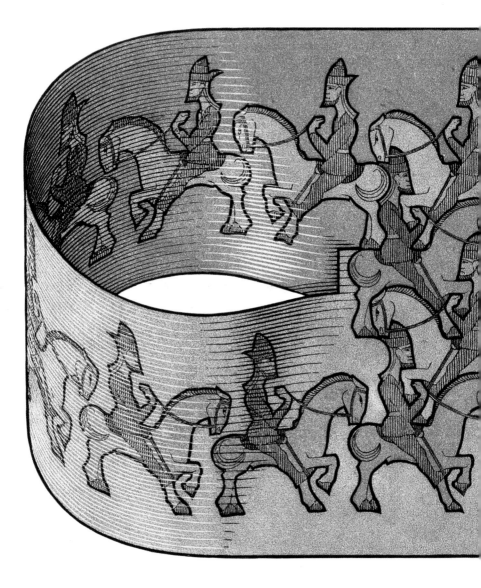

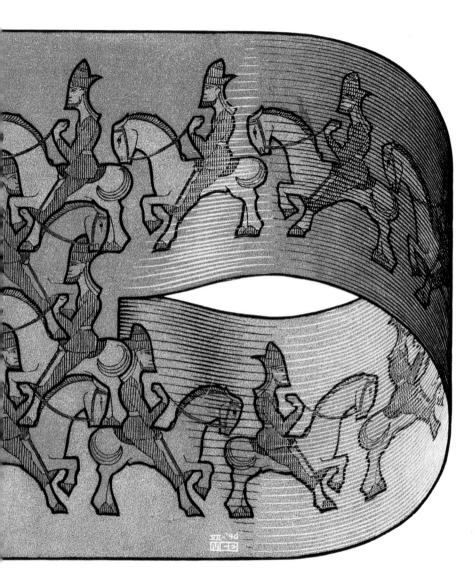

Horseman.

Cavaliers.

Reiter.

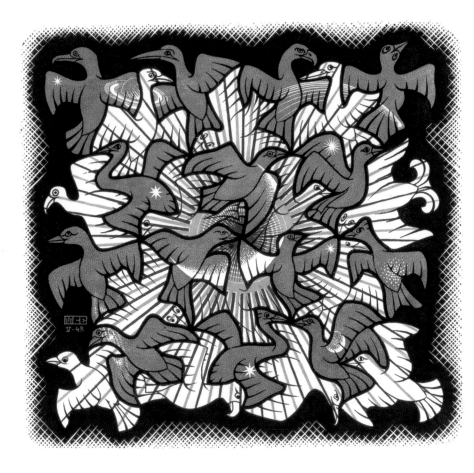

Sun and Moon.
Soleil et lune.
Sonne und Mond.

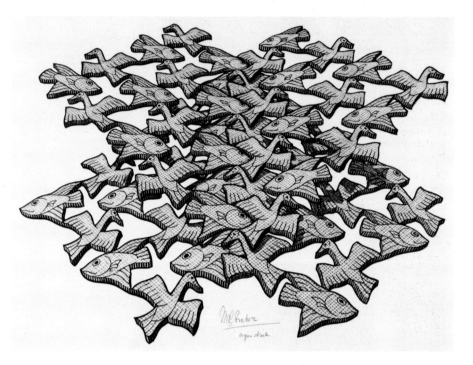

Two Intersecting Planes.

Deux plans sécants.

Zwei sich schneidende Flächen.

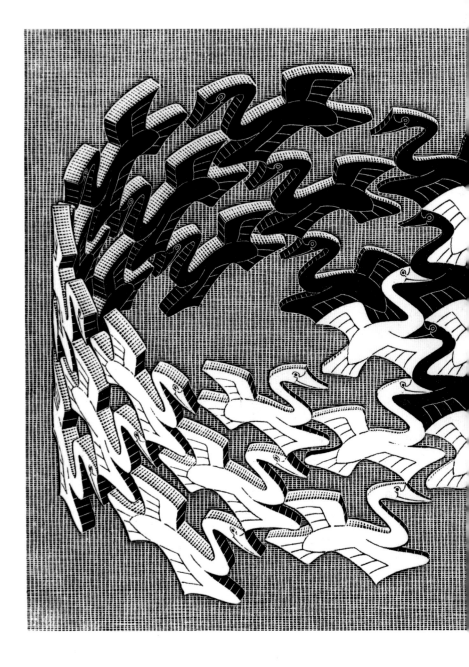

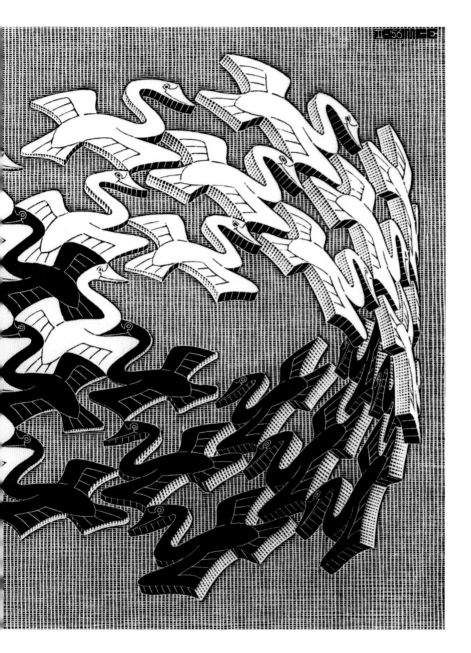

Swans (White Swans, Black Swans).

Les cygnes (Cygnes blancs, cygnes noirs).

Schwäne (Weiße Schwäne, Schwarze Schwäne).

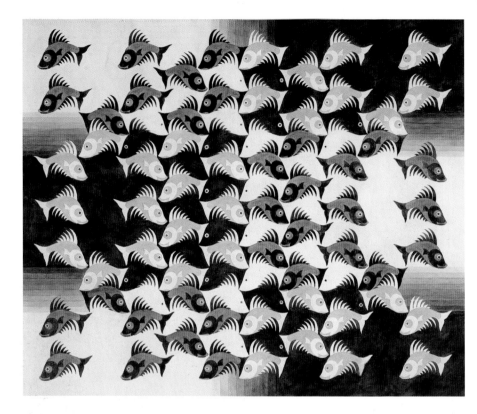

Design drawing for intarsia wood panels with fish for Leiden Stadhuis.
Dessin pour des panneaux de bois intarsia avec des poissons pour Leiden Stadhuis.
Zeichenentwurf für Intarsien mit Fischen für das Stadhuis in Leiden.

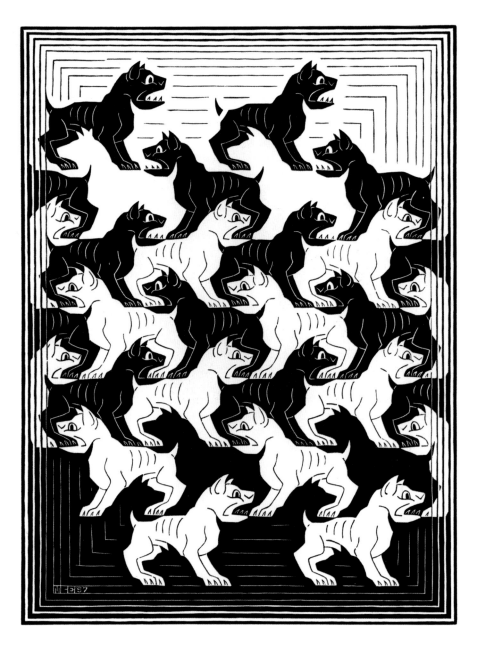

[Regular Division of the Plane IV].

[Division régulière du plan IV].

[Regelmäßige Flächenaufteilung IV].

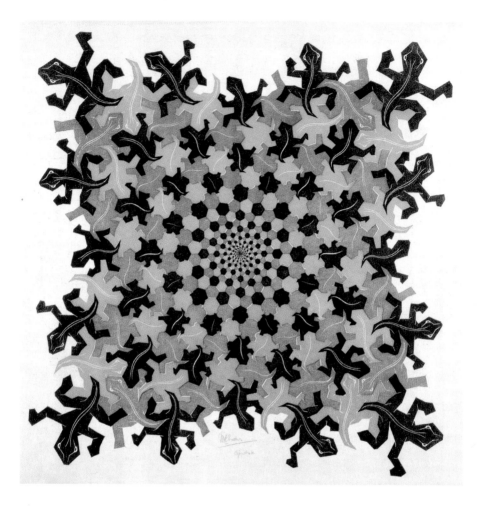

Development II.
Développement II.
Entwicklung II.

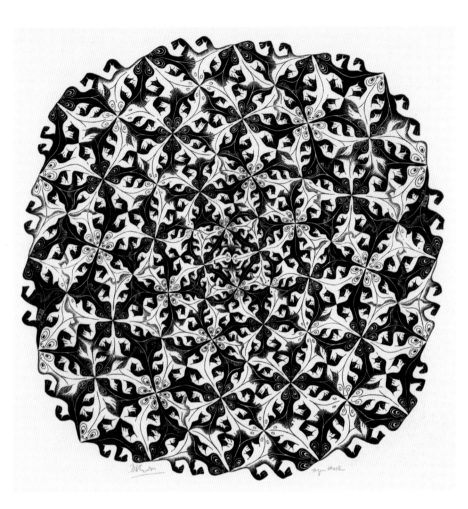

Division.
Division.
Division.

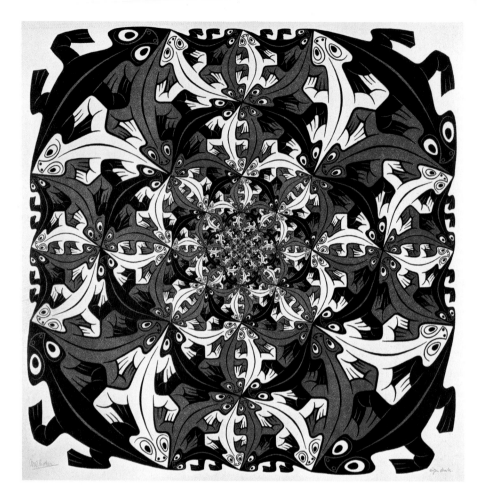

Smaller and Smaller.
De plus en plus petit.
Kleiner und Kleiner.

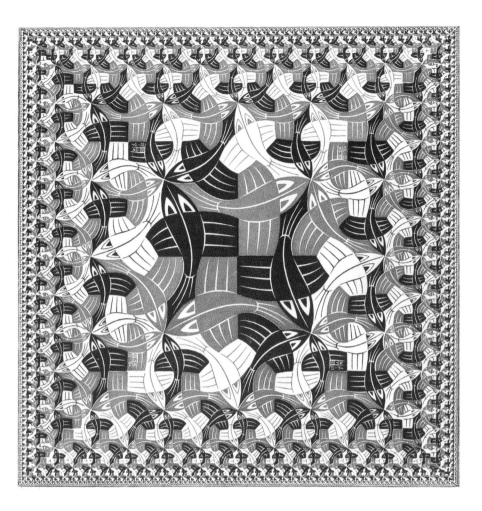

Square Limit.
Limite carrée.
Quadratlimit.

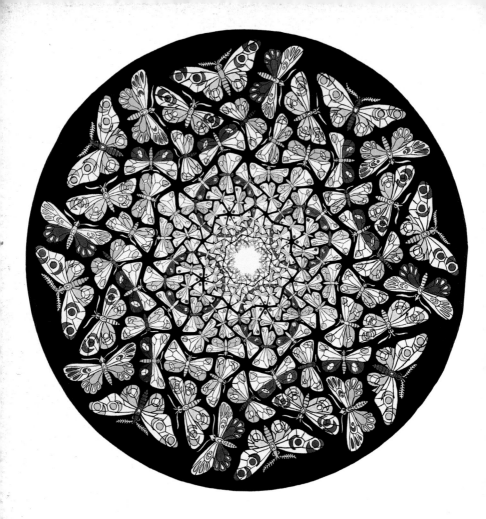

76 [Butterflies].
 [Papillons].
 [Schmetterlinge].

77 Design drawing for ceiling for Demonstration Laboratory, Philips Company.
 Dessin pour le plafond du laboratoire de démonstration, entreprise Philips.
 Zeichenentwurf für die Decke des Demonstrationslabors für das Unternehmen Philips.

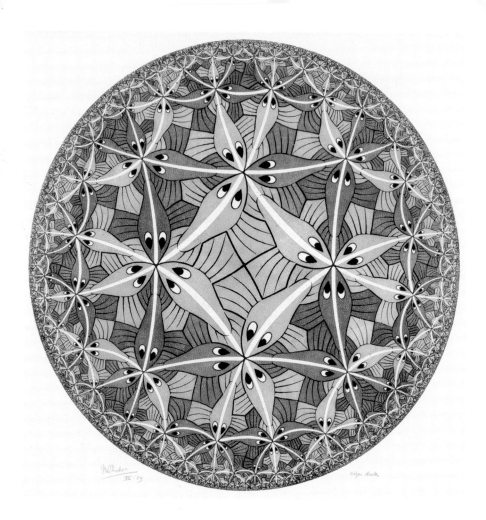

Circle Limit III.
Limite circulaire III.
Kreislimit III.

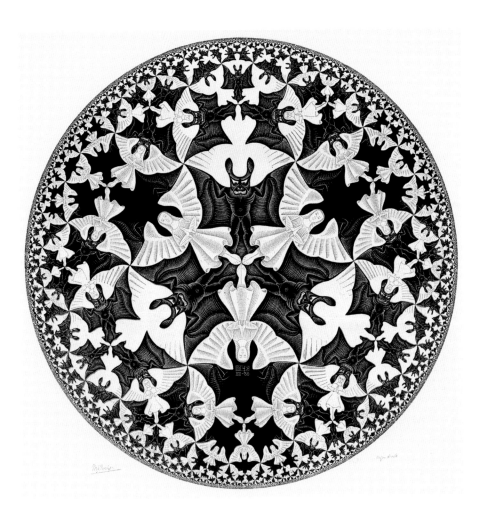

Circle Limit IV (Heaven and Hell).
Limite circulaire IV (Enfer et paradis).
Kreislimit IV (Himmel und Hölle).

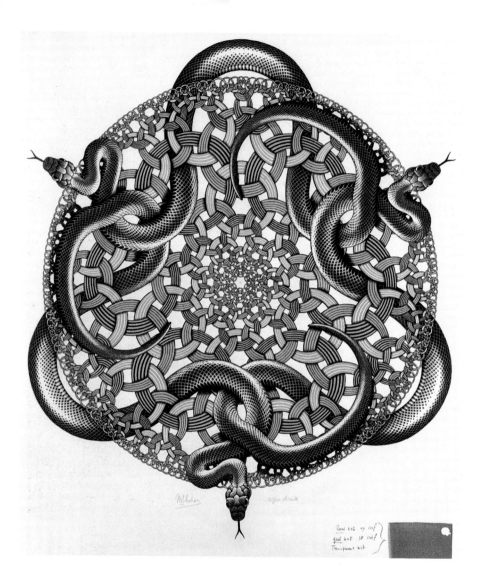

Snakes.

Serpents.

Schlangen.

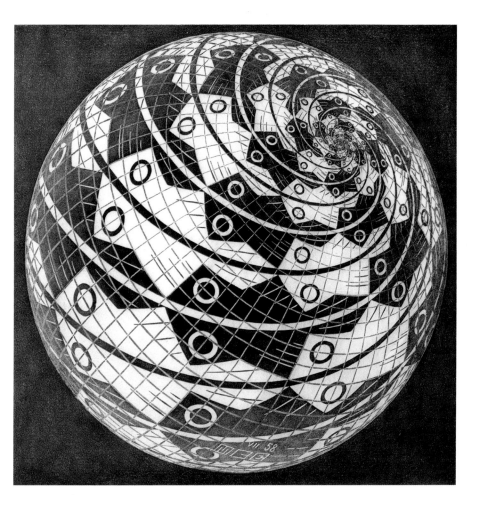

Sphere Surface with Fish.
Surface sphérique avec poisson.
Kugeloberfläche mit Fischen.

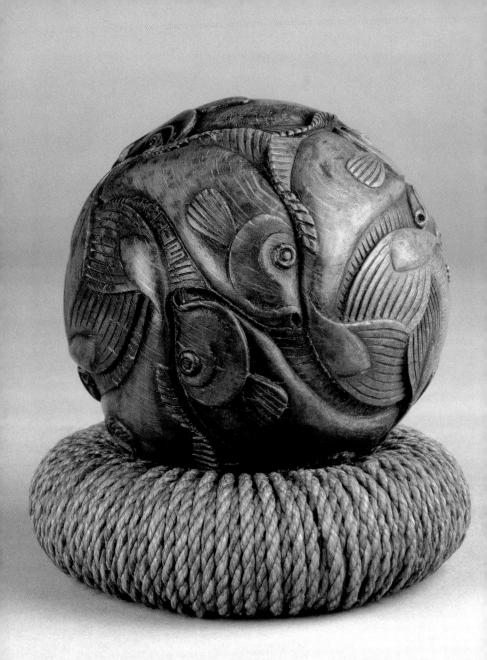

82 Carved sphere with fish.
 Sphère gravée avec poisson.
 Geschnitzte Kugel mit Fisch.

83 The tin designed by Escher in 1963 for the Verblifa Company.
 Boîte métallique créée par Escher en 1963 pour l'entreprise Verblifa.
 Die Dose, die Escher 1963 für das Unternehmen Verblifa entwarf.

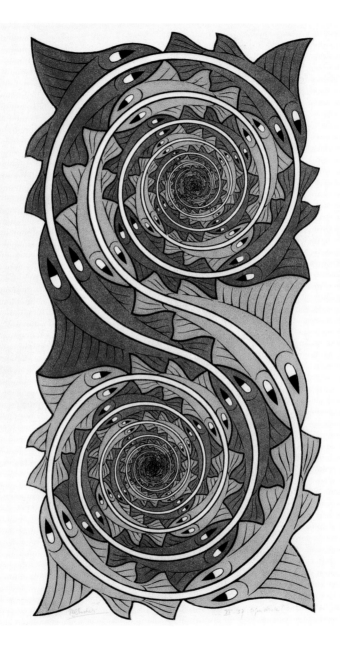

Whirlpools.

Tourbillons.

Strudel.

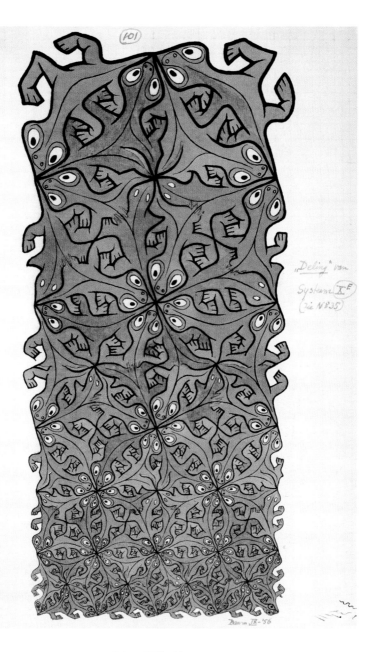

Escher no. 101 [Lizards].
Escher no. 101 [Lézards].
Escher Nr. 101 [Eidechsen].

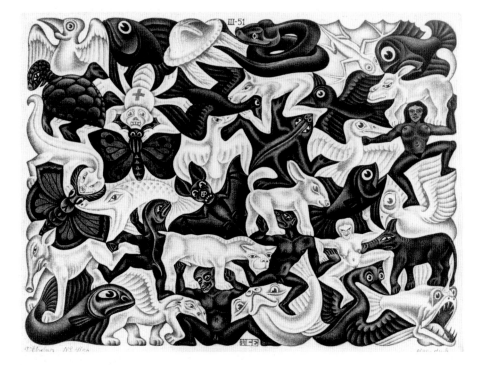

III-51

Plane Filling I.
Remplissage du plan I.
Flächenfüllung I.

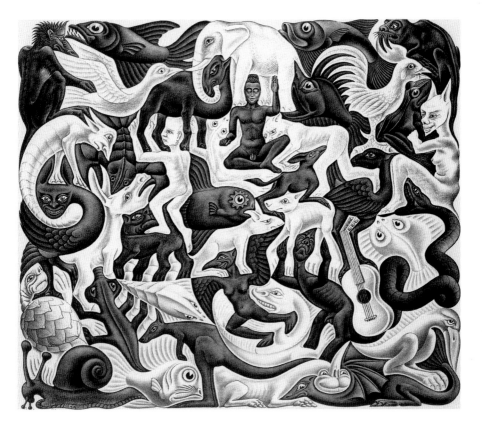

Plane Filling II.
Remplissage du plan II.
Flächenfüllung II.

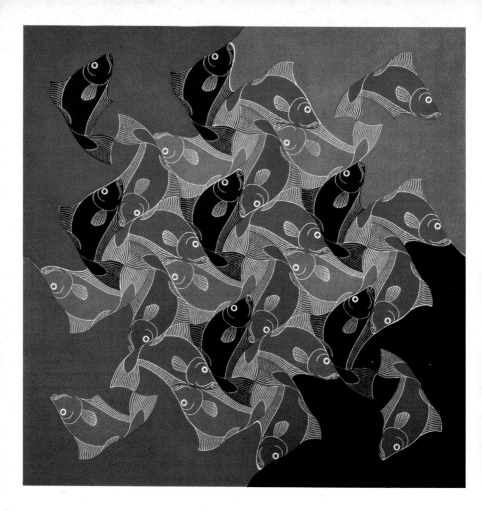

88 [Fish].
 [Poisson].
 [Fisch].

99 Hand-printed design of fish.
 Dessin d'un poisson imprimé à la main sur soie.
 Handgedrucktes Design eines Fisches auf Seide.

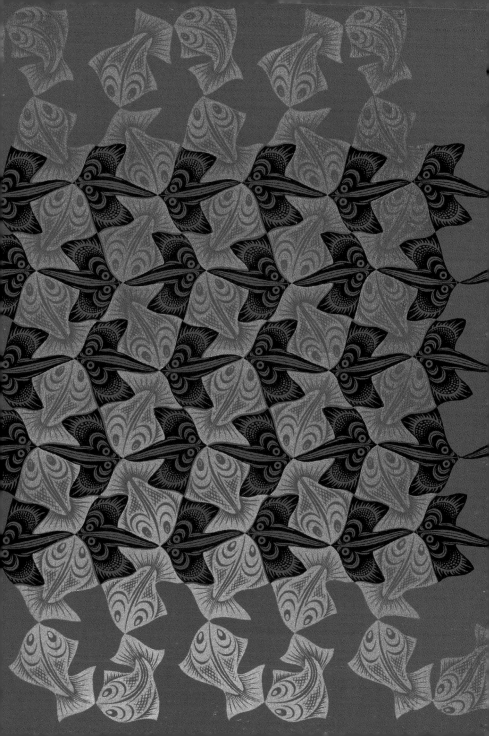

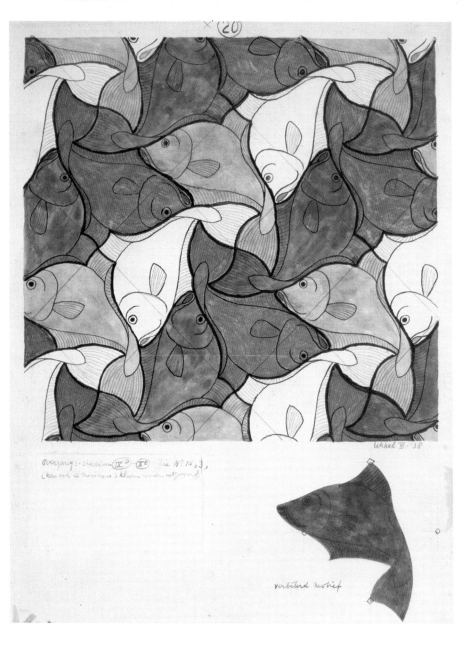

90 Escher no. 20 [Fish].
 Escher no. 20 [Poisson].
 Escher Nr. 20 [Fisch].

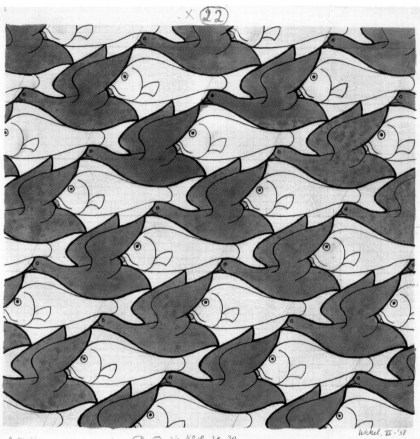

2 motieven: overgangs systeem (IA)—(IA) zie No 18, 29, 30

Wikkel, VI -'38

91 Escher no. 22 [Bird/Fish].
 Escher no. 22 [Oiseau/Poisson].
 Escher Nr. 22 [Vogel/Fisch].

92 | 93 Escher no. 58 [Two Fish].
 Escher no. 58 [Deux Poissons].
 Escher Nr. 58 [Zwei Fische].

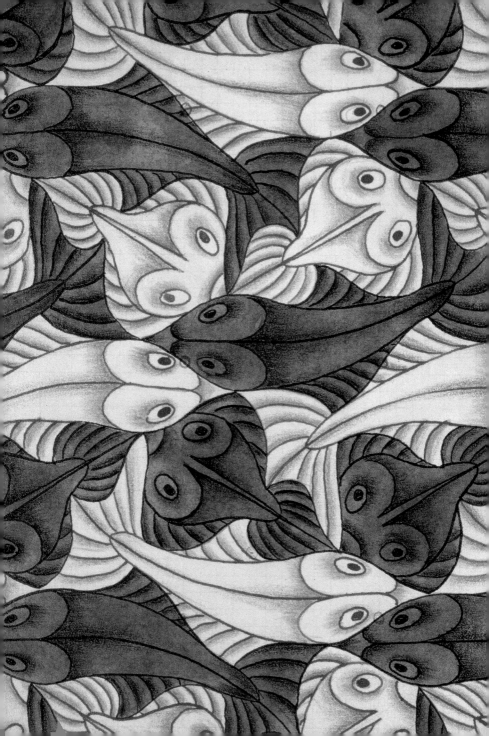

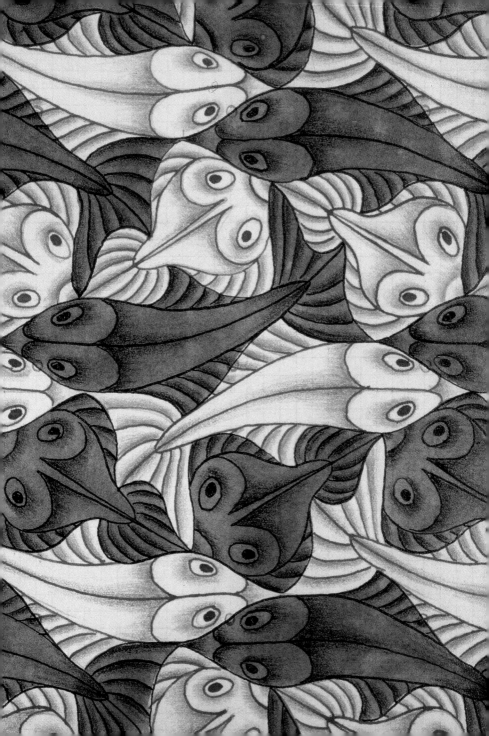

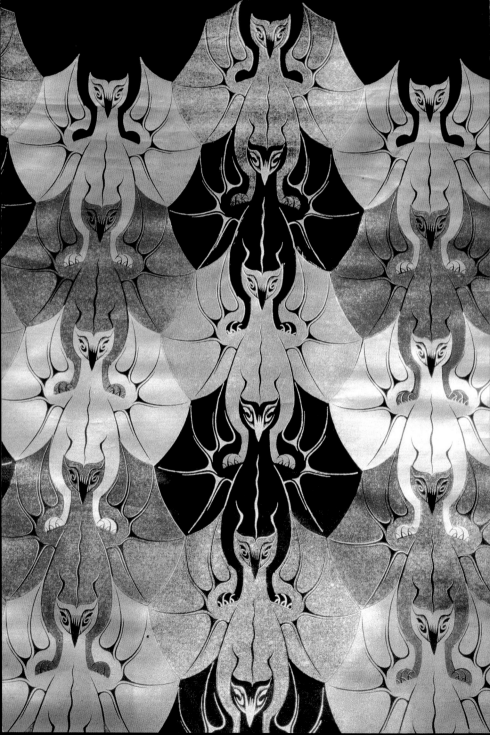

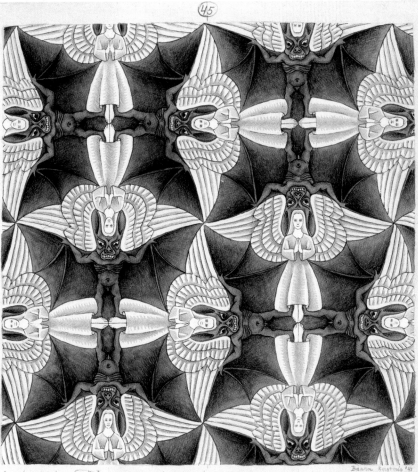

2 • moheven • system ⟨Ⅰ E⟩ᴬ, symmetrisch volgens een diametrale as.

Baarn Kerstmis '47

94 Periodic Design A1 [Bat].
 Dessin Périodique A1 [Chauve-Souris].
 Periodisches Design A1 [Fledermaus].

95 Escher no. 45 [Angel-Devil].
 Escher no. 45 [Ange-Démon].
 Escher Nr. 45 [Engel-Teufel].

96 | 97 Escher no. 66 [Winged Lion].
 Escher no. 66 [Le Lion Ailé].
 Escher Nr. 66 [Geflügelter Löwe].

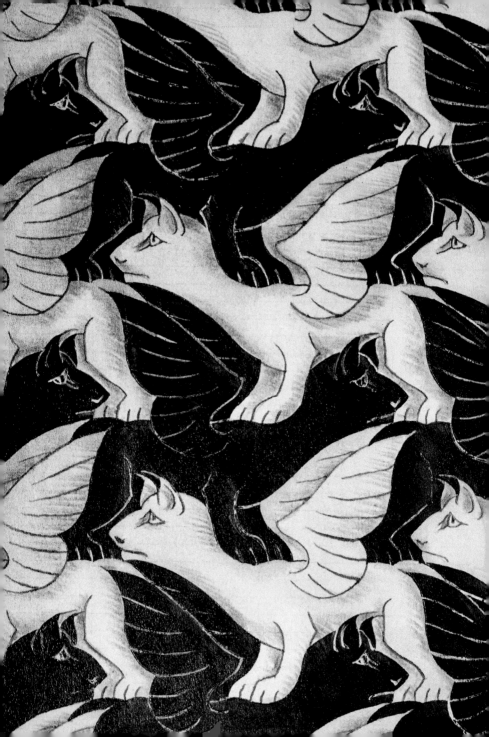

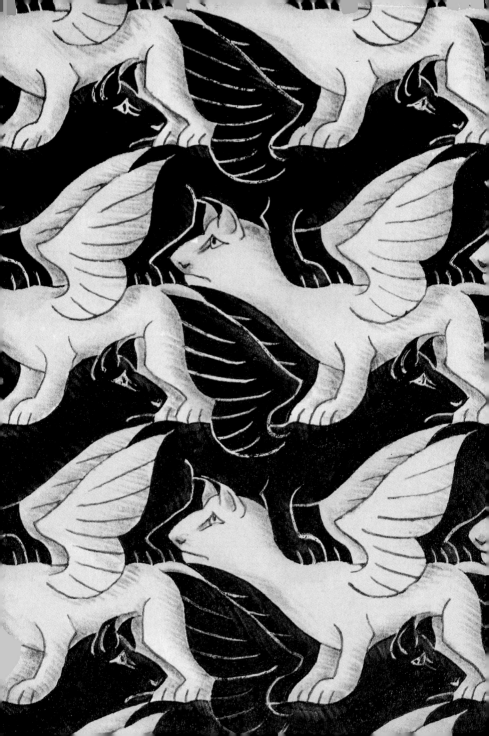

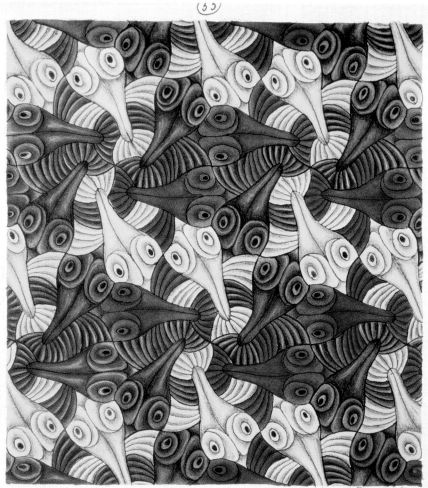

Δ- system I·B3 type 1

Baarn XI·'42

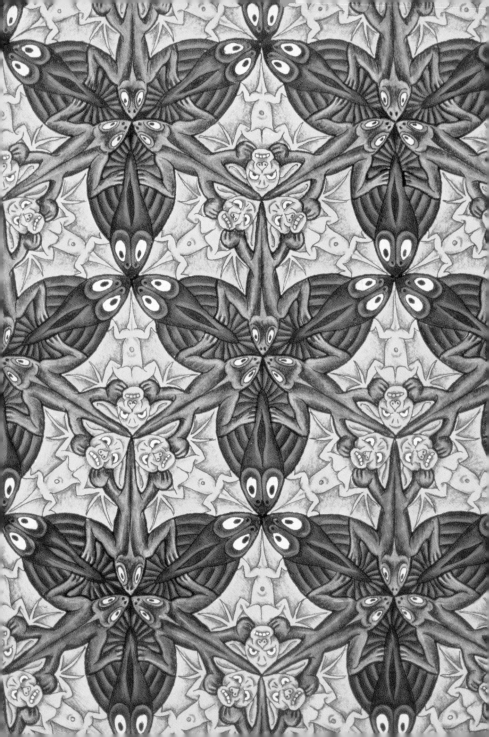

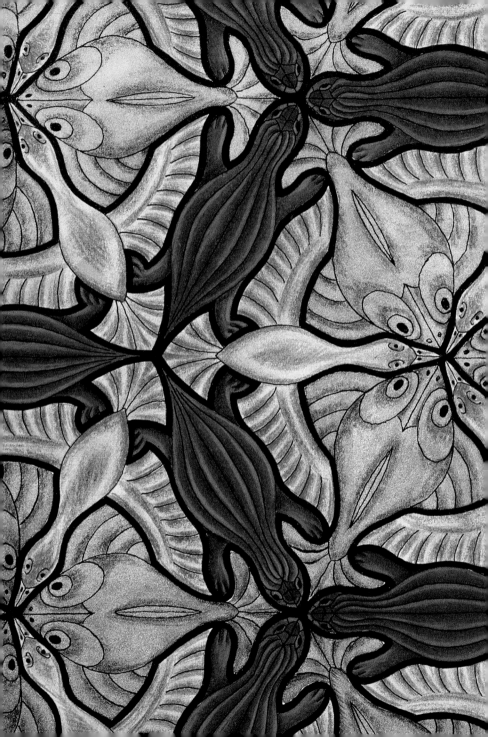

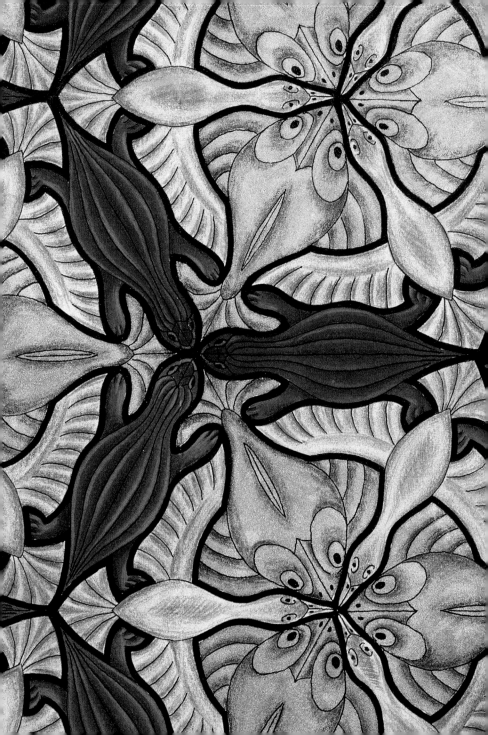

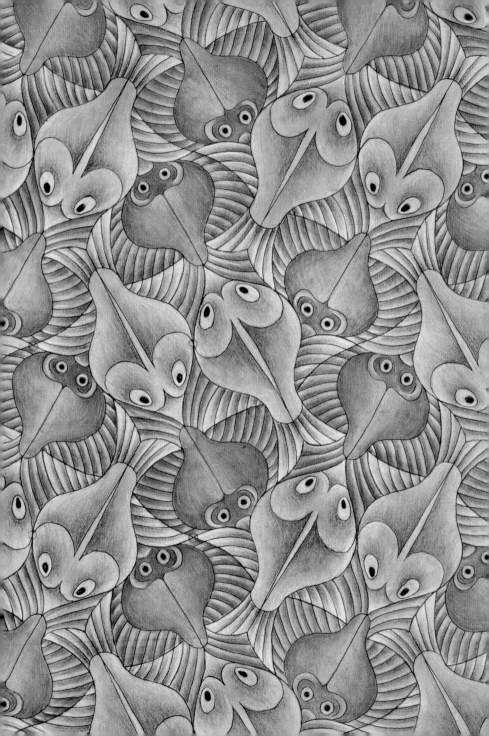

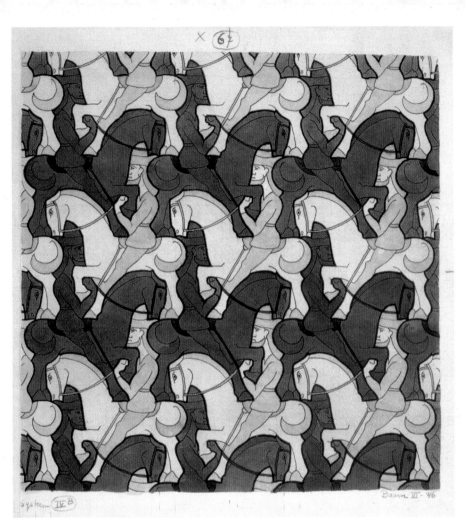

102 Escher no. 46 [Two Fish].
 Escher no. 46 [Deux Poissons].
 Escher Nr. 46 [Zwei Fische].

103 Escher no. 67 [Horseman].
 Escher no. 67 [Cavalier].
 Escher Nr. 67 [Reiter].

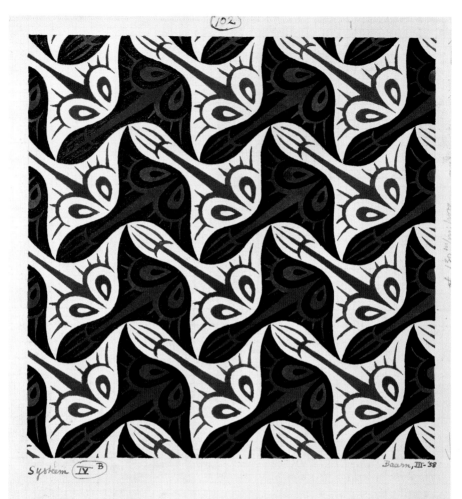

System (IV) B Baarn, III-'58

104 Escher no. 102 [Ray Fish].
 Escher no. 102 [Raie].
 Escher Nr. 102 [Rochen].

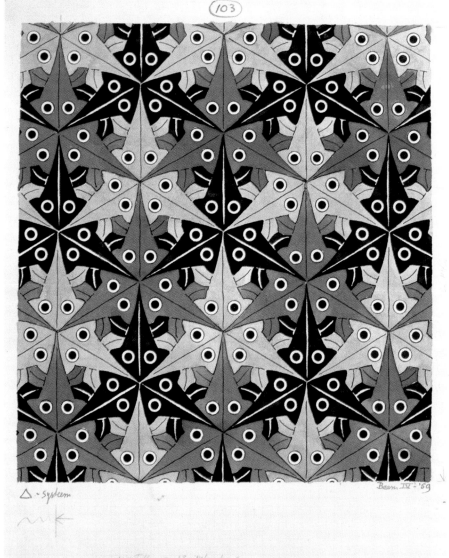

△-systeem

Baarn. IV. '59

105 Escher no. 103 [Fish].
 Escher no. 103 [Poisson].
 Escher Nr. 103 [Fisch].

106 | 107 Escher no. 130 [Fish/Horse].
 Escher no. 130 [Poisson/Cheval].
 Escher Nr. 130 [Fisch/Pferd].

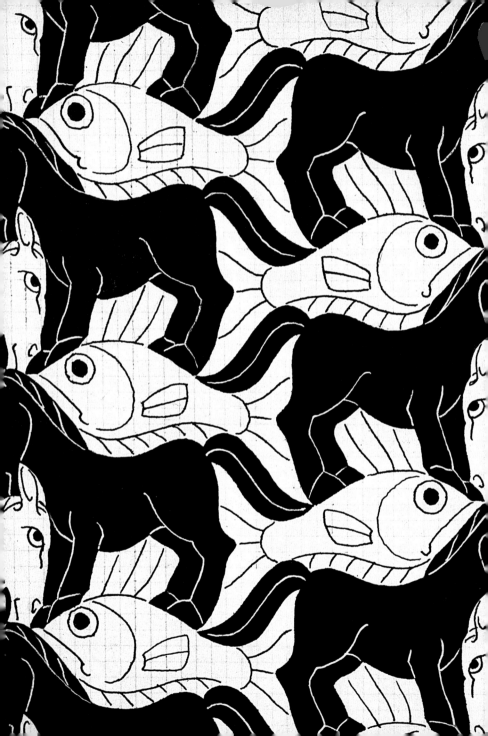

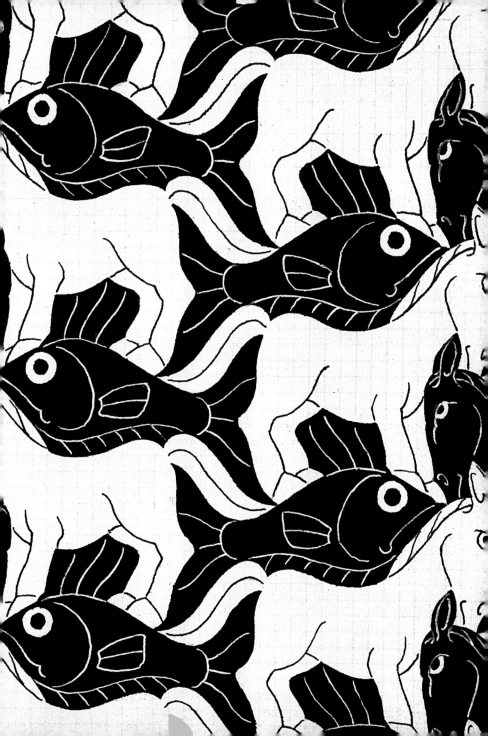

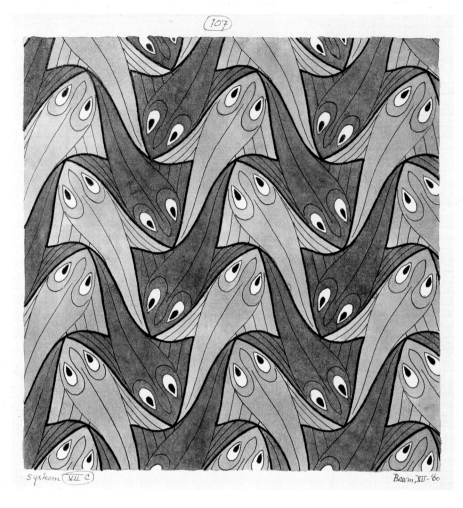

System (VII C) Baarn, XII - '60

108 Escher no. 107 [Fish].
 Escher no. 107 [Poisson].
 Escher Nr. 107 [Fisch].

109 Escher no. 109 [Creeping Creature]. 110 | 111 Escher no. 115 [Flying Fish/Bird].
 Escher no. 109 [Créature Rampante]. Escher no. 115 [Poisson Volant/Oiseau].
 Escher Nr. 109 [Kriechende Kreatur]. Escher Nr. 115 [Fliegender Fisch/Vogel].

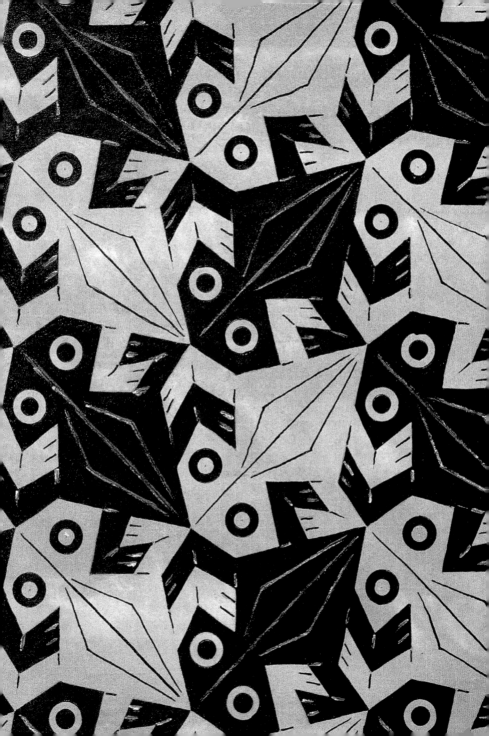

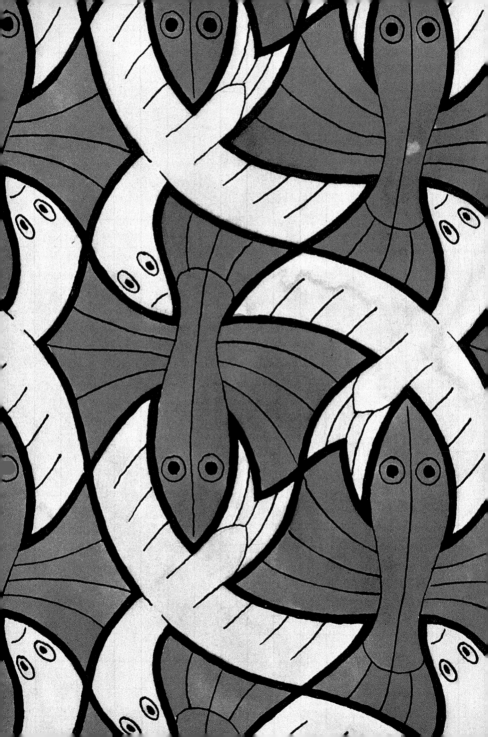

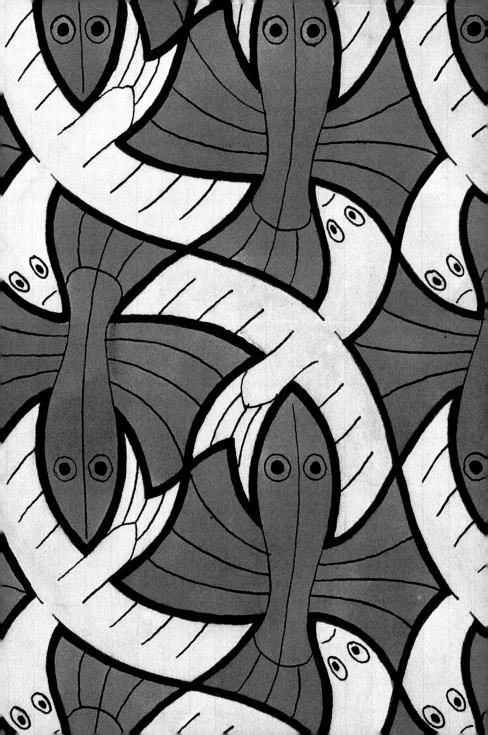

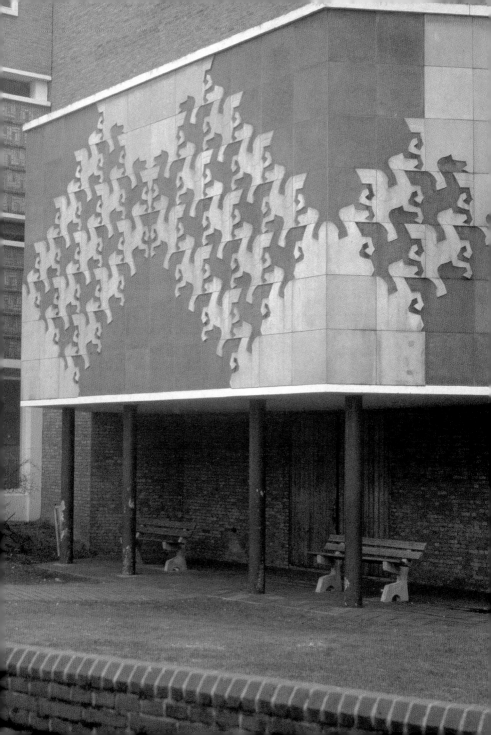

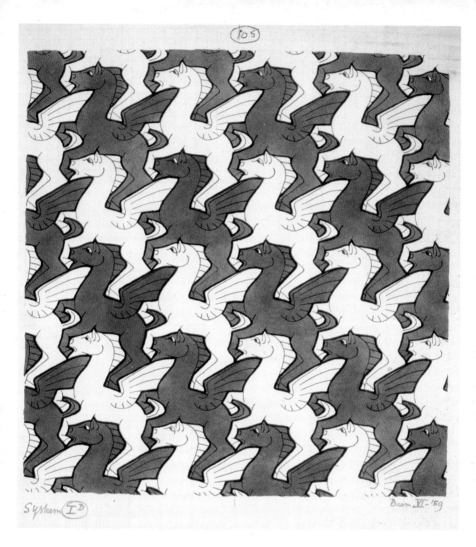

112 Design for tiled facade for the entrance of a school in The Hague.
Création pour la façade en mosaïque de l'entrée de l'école de La Haye.
Entwurf einer Kachelfassade für den Eingang einer Schule in Den Haag.

113 Escher no. 105 [Pegasus].
Escher no. 105 [Pégase].
Escher Nr. 105 [Pegasus].

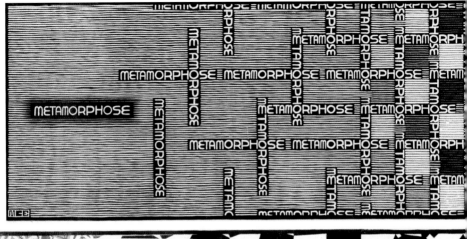

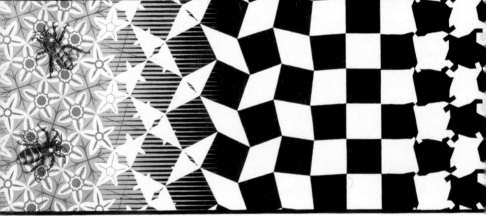

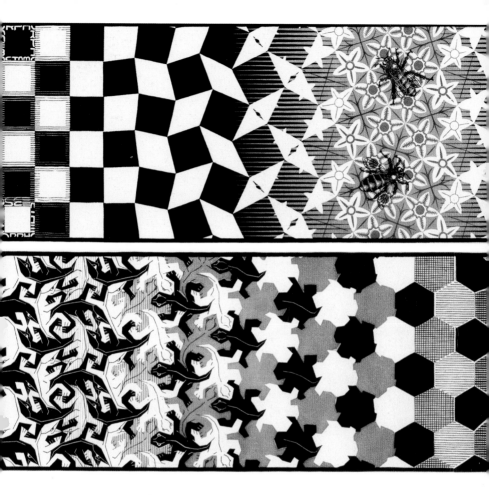

114–121 Metamorphosis III.
Métamorphose III.
Métamorphose III.

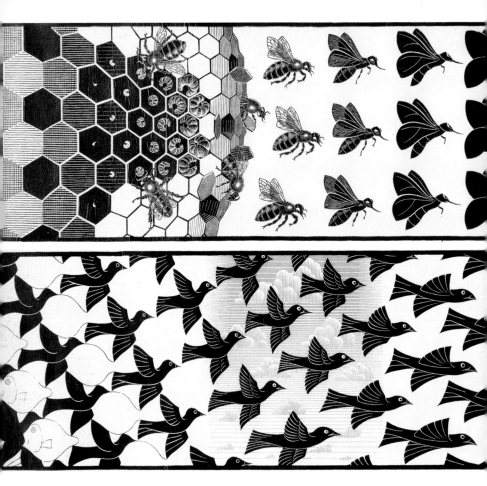

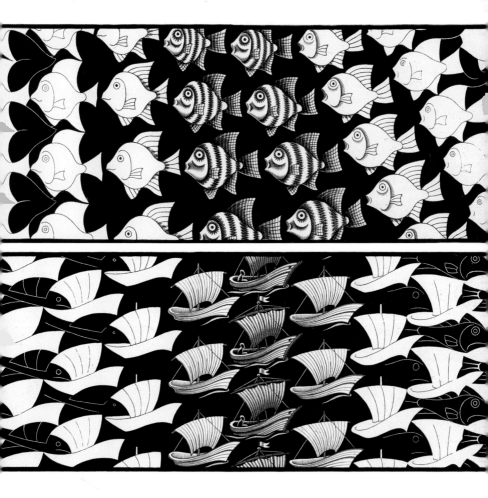

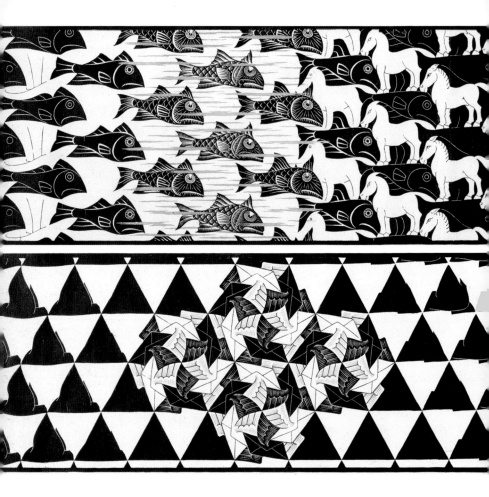

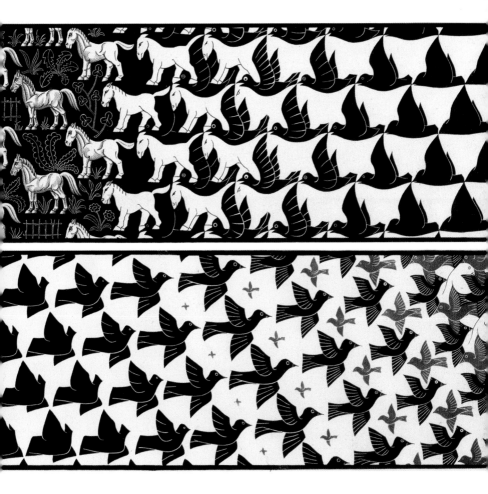

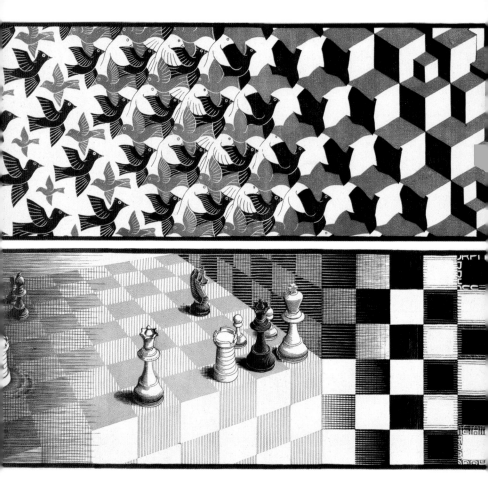

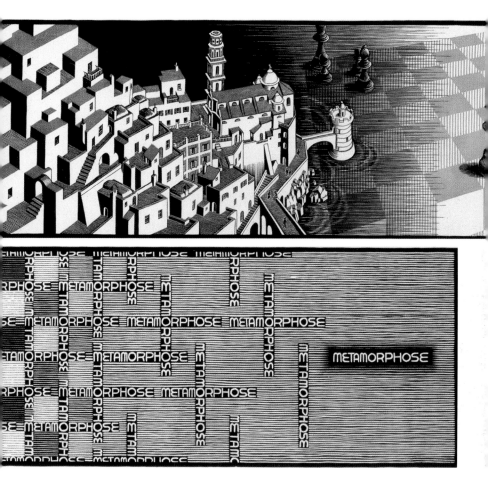

UNLIMITED SPACES
ESPACES ILIMITÉS
DER UNBEGRENZTE RAUM

Depth.
Profondeur.
Tiefe.

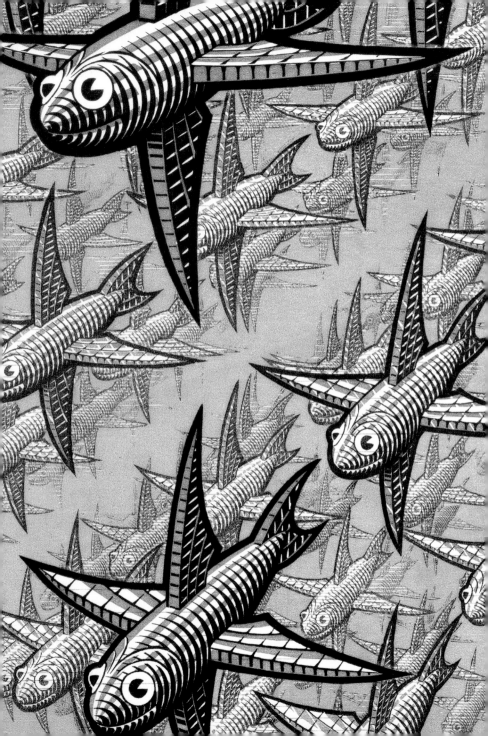

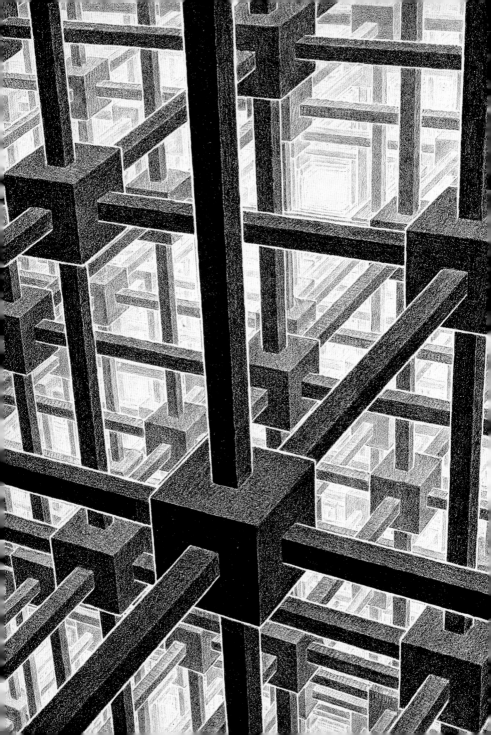

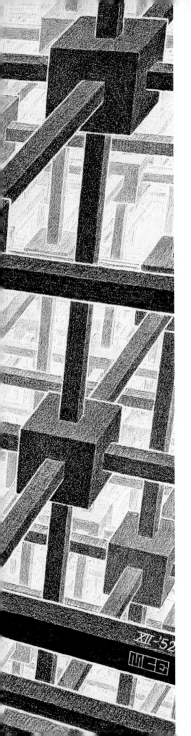

Cubic Space Division (Cubic Space Filling).

Division d'espace cubique (Remplissage d'espace cubique).

Kubische Raumaufteilung (Kubische Raumfüllung).

SPATIAL RINGS AND SPIRALS
CERCLES ET SPIRALES DANS L'ESPACE
RÄUMLICHE KREISE UND SPIRALEN

Knots.
Nœuds.
Knoten.

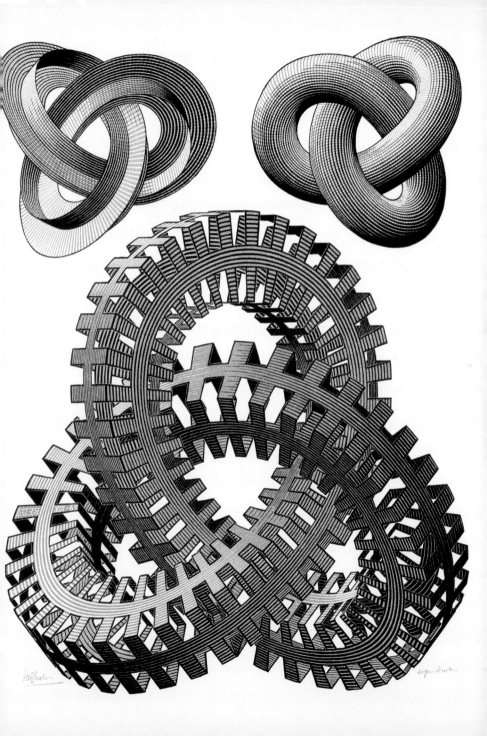

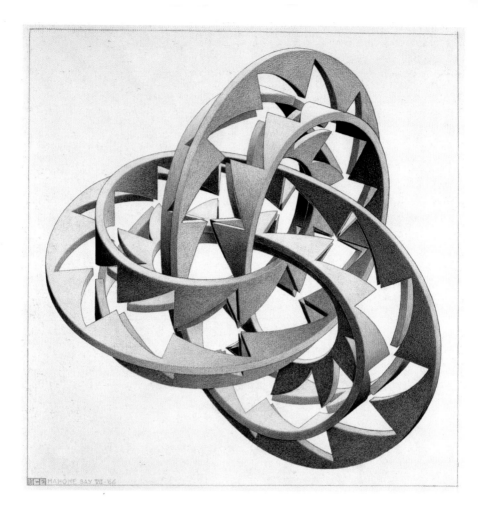

[Study for Knot].
[Étude pour Nœuds].
[Studie für Knoten].

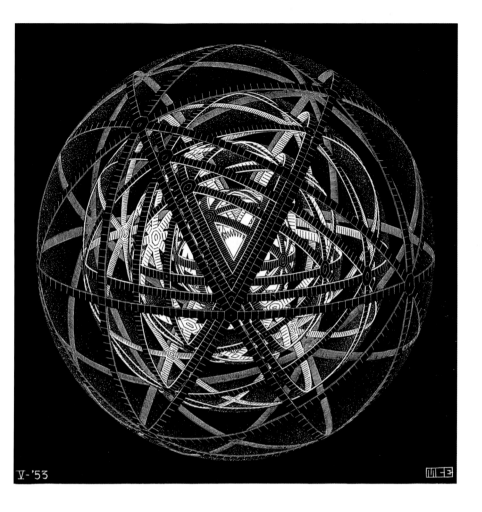

V-'53

MCE

Concentric Rinds (Concentric Space Filling/Regular Sphere Division).

Écorces concentriques (Remplissage d'espace concentrique/Division de sphère régulière).

Konzentrische Schalen (Konzentrische Flächenteilung/Gleichmäßige Kugelteilung).

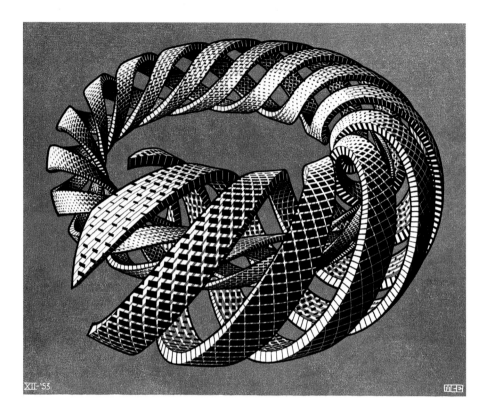

XII-'53

Spirals.
Spirales.
Spiralen.

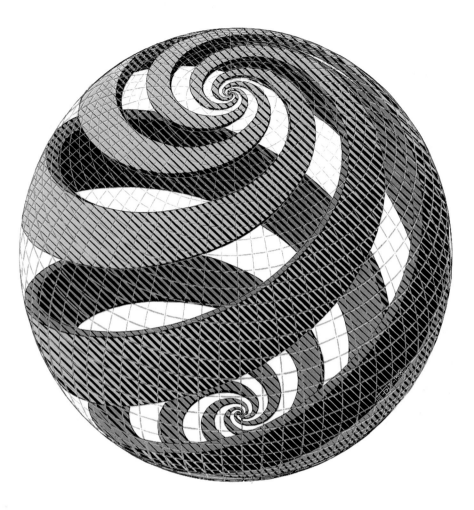

Sphere Spirals.
Spirales sphériques.
Kugelspiralen.

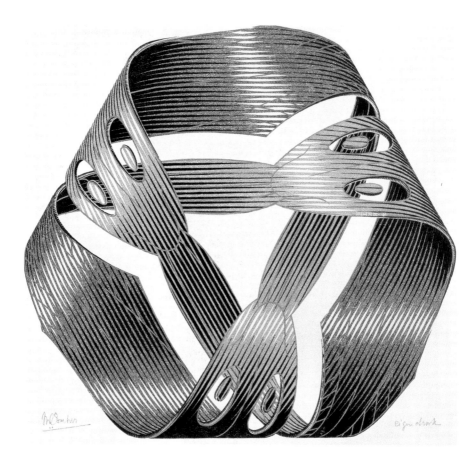

Möbius Strip I.
Le ruban de Möbius I.
Möbiusband I.

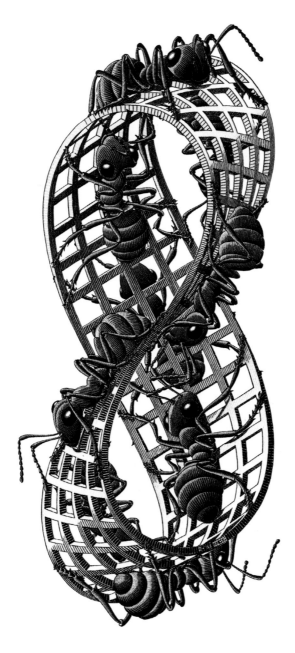

Möbius Strip II (Red Ants).
Le ruban de Möbius II (Fourmis rouges).
Möbiusband II (Rote Ameisen).

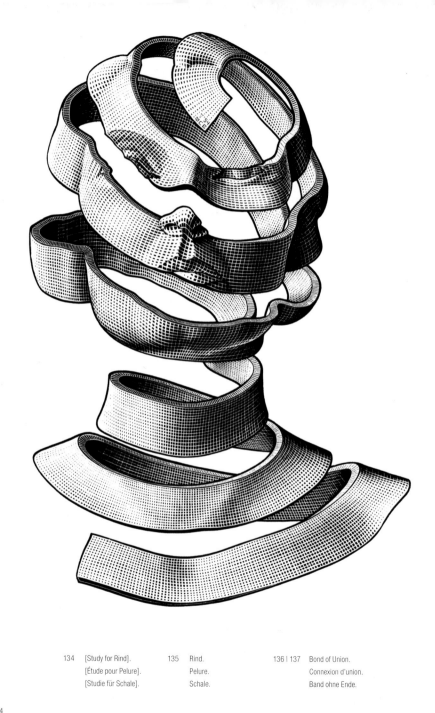

134 [Study for Rind]. 135 Rind. 136 | 137 Bond of Union.
 [Étude pour Pelure]. Pelure. Connexion d'union.
 [Studie für Schale]. Schale. Band ohne Ende.

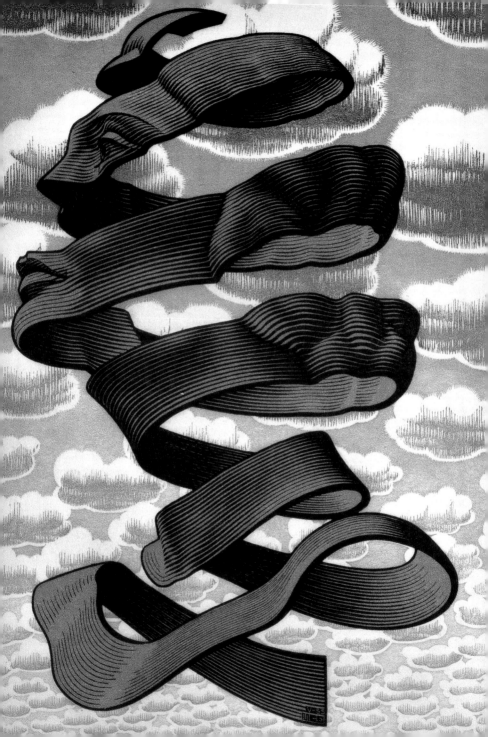

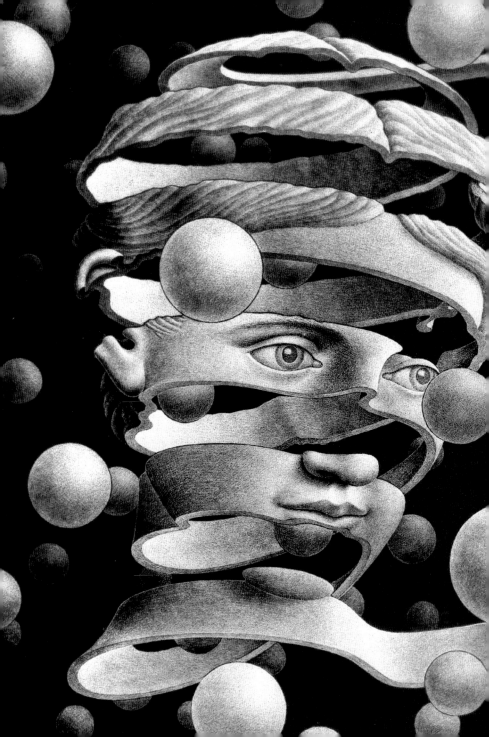

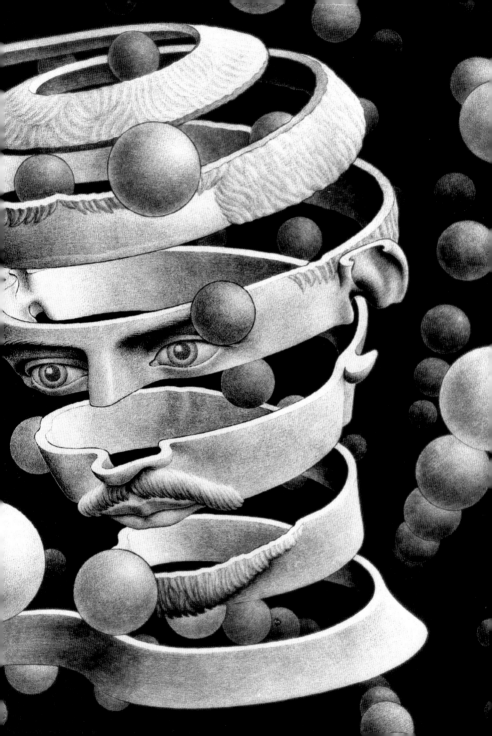

MIRROR IMAGES
RÉFLEXIONS
SPIEGELUNGEN

Hand with Reflecting Sphere (Self-Portrait in Spherical Mirror).
Main au globe (Autoportrait dans un miroir sphérique).
Hand mit reflektierender Kugel (Selbstporträt in kugelförmigem Spiegel).

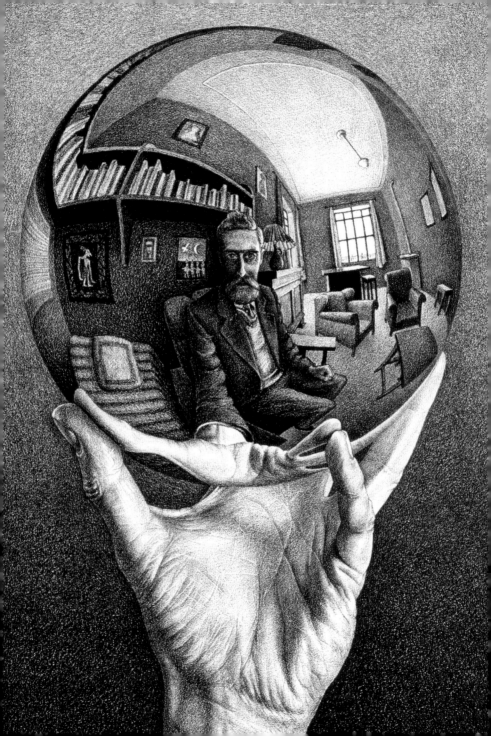

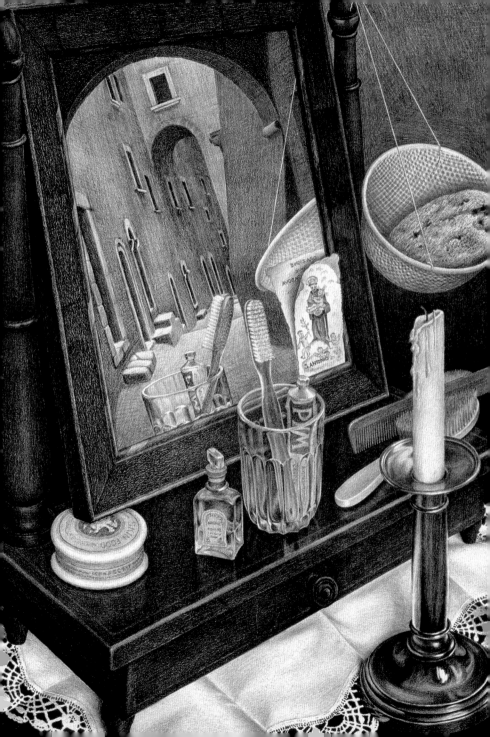

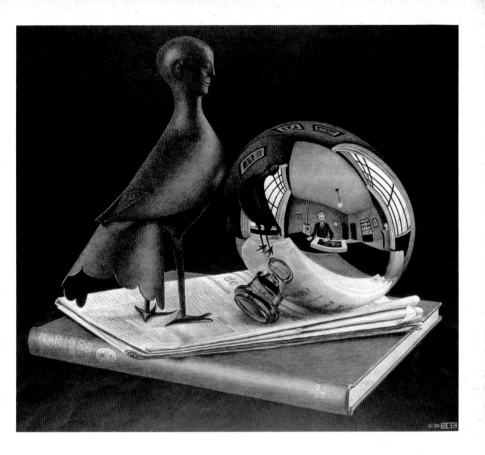

140 Still Life with Mirror.
 Nature morte au miroir.
 Stillleben mit Spiegel.

141 Still Life with Spherical Mirror.
 Nature morte au miroir sphérique.
 Stillleben mit Kugelförmigen Spiegel.

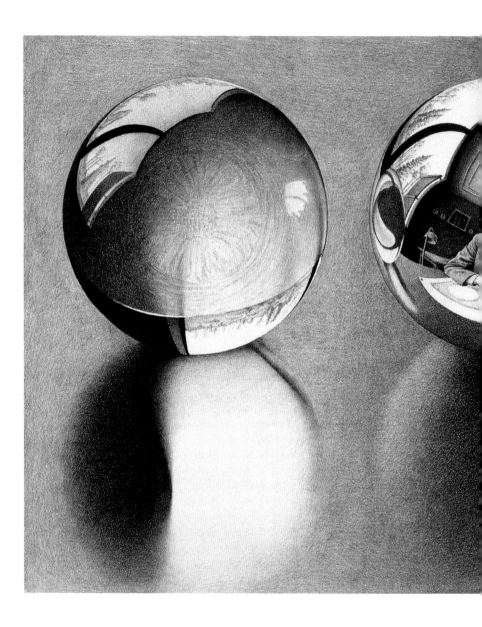

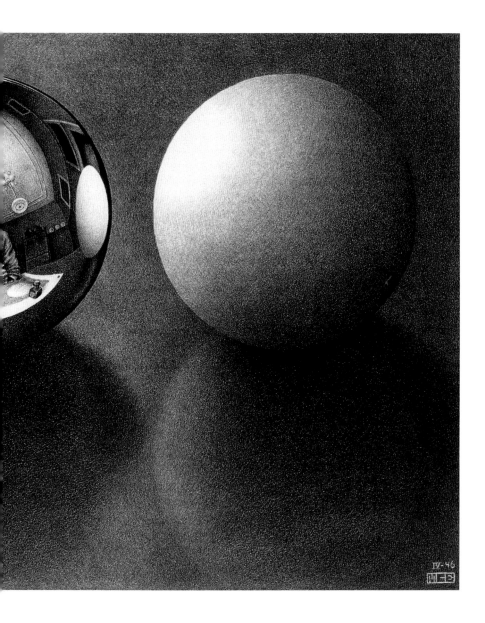

Three Spheres II.
Trois sphères II.
Drei Kugeln II.

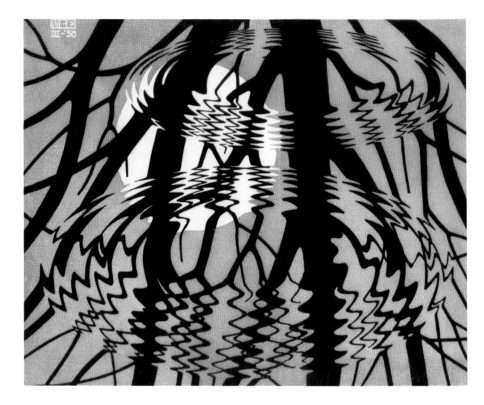

Rippled Surface.
Surface ondulée.
Gewellte Oberfläche.

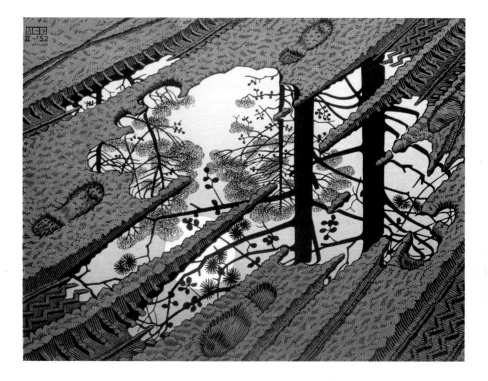

Puddle.

Flaque d'eau.

Pfütze.

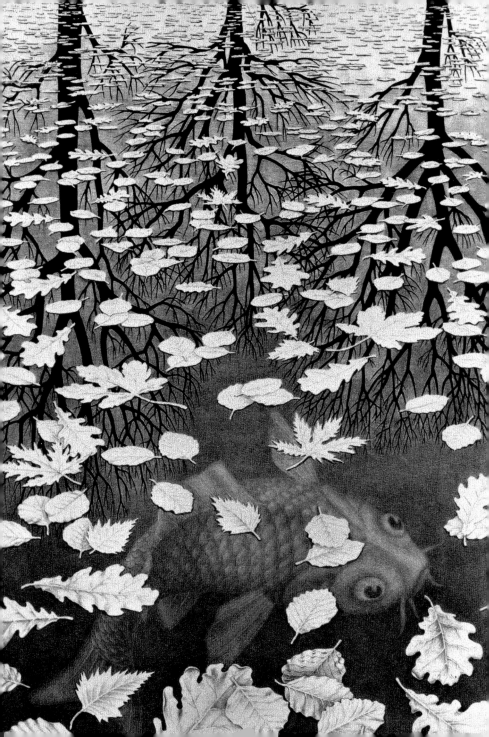

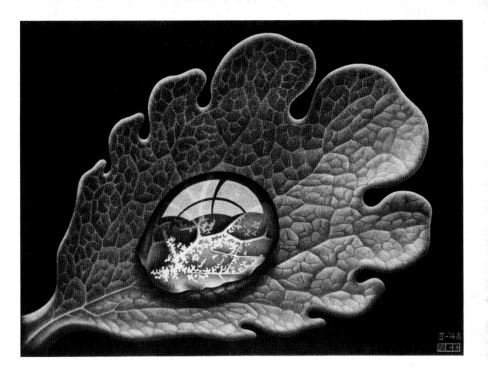

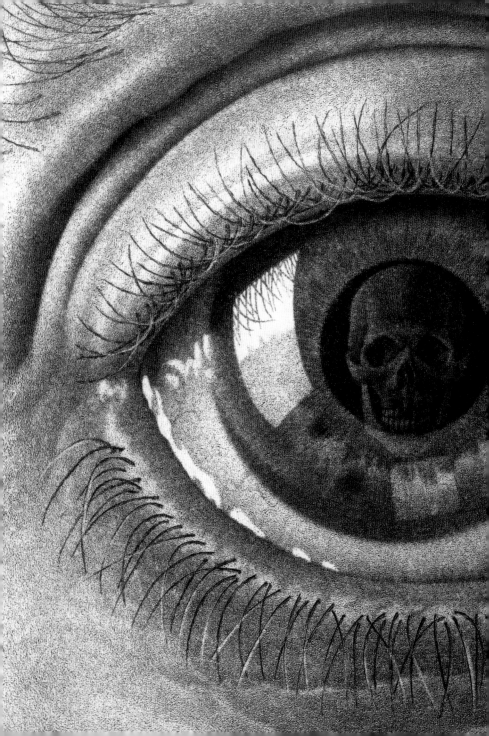

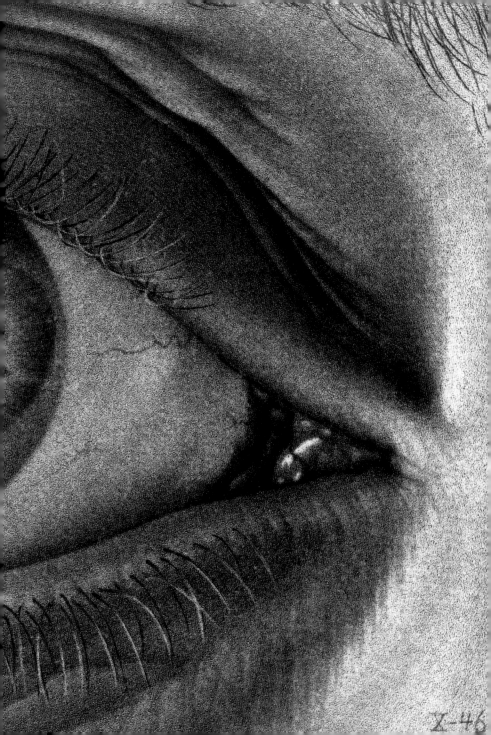

INVERSION
INVERSION
INVERSIONEN

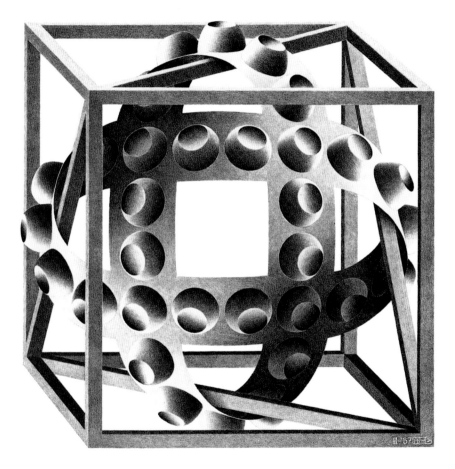

Cube with Ribbons.

Cube aux rubans.

Würfel mit magischen Bändern.

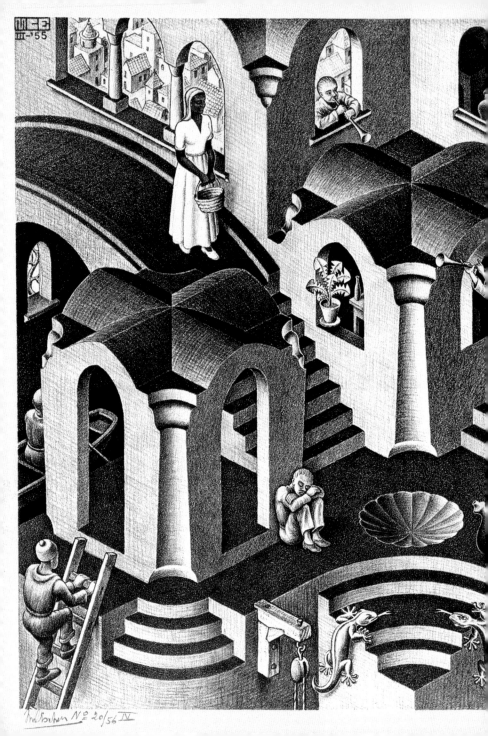

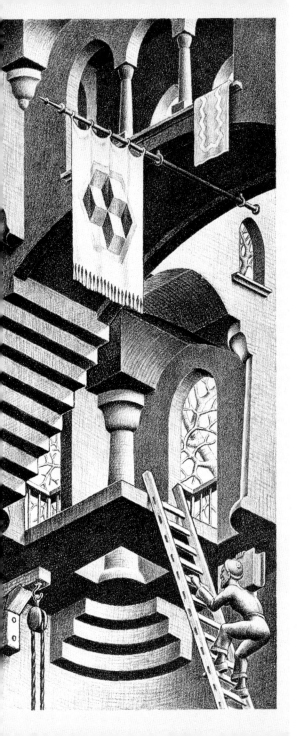

Convex and Concave.
Convexe et concave.
Konkav und Konvex.

POLYHEDRONS
POLYÈDRES
POLYEDER

Stars.
Étoiles.
Sterne.

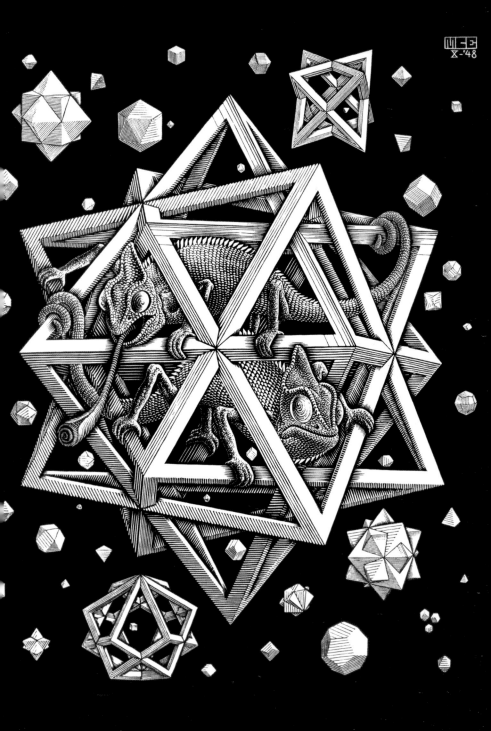

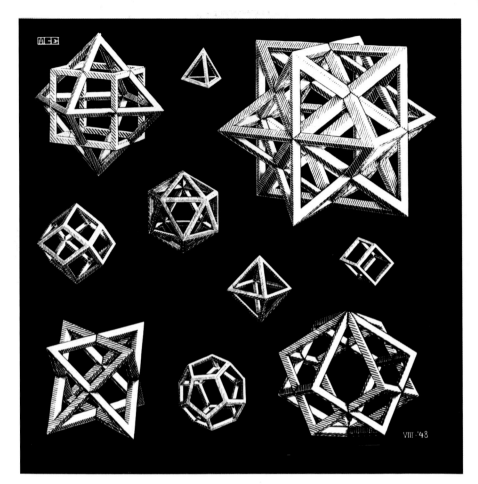

[Study for Stars].
[Étude pour Étoiles].
[Studie für Sterne].

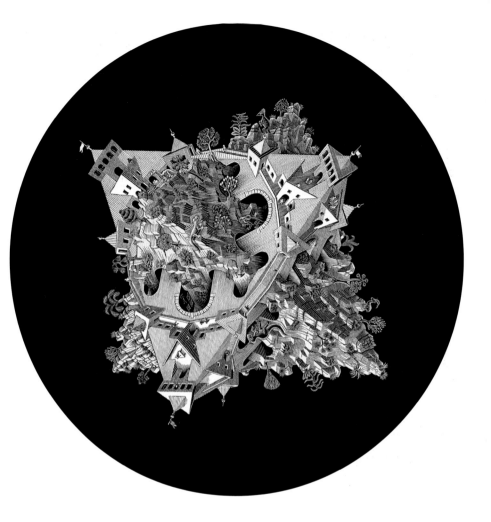

Double Planetoid (Double Planet).
Double planétoïde.
Doppelplanetoid (Doppelplanet).

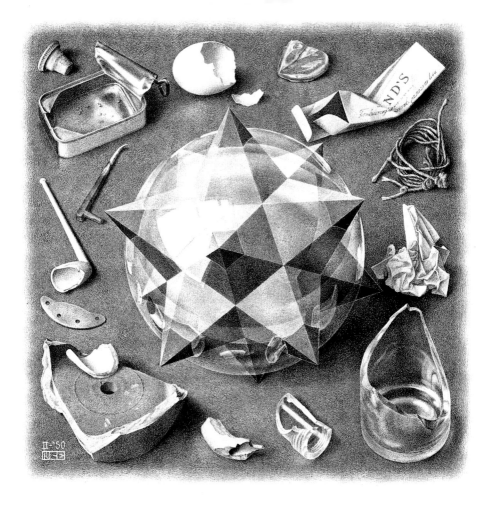

Contrast (Order and Chaos).
Contraste (Ordre et chaos).
Kontrast (Ordnung und Chaos).

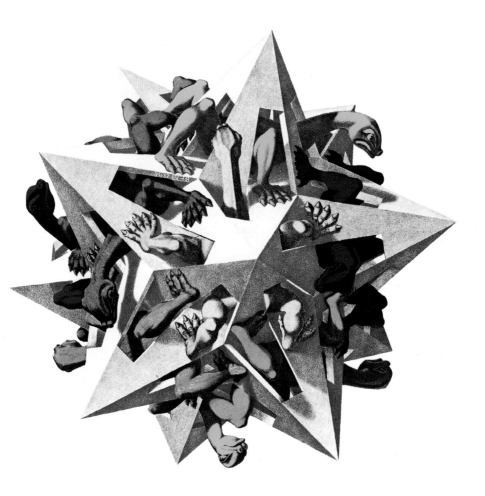

Gravity.
Gravité.
Schwerkraft.

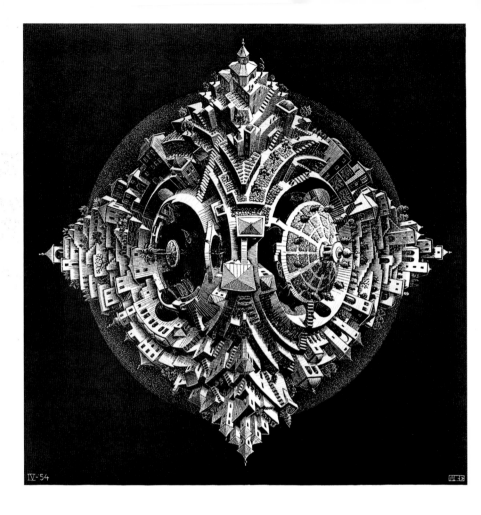

IV-54

Tetrahedral Planetoid (Tetrahedral Planet).

Planétoïde tétraédrique.

Vierflächenplanetoid (Vierflächenplanet).

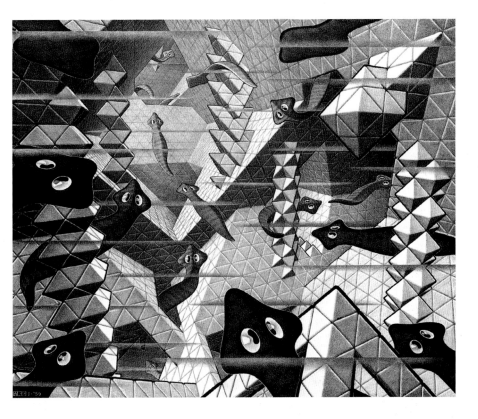

Flatworms.
Vers plats.
Plattwürmer.

RELATIVITIES
RELATIVITÉS
RELATIVITÄTEN

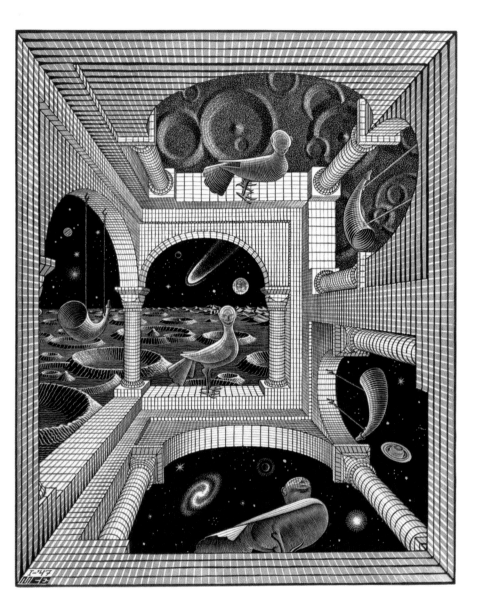

Other World.
L'autre monde.
Andere Welt.

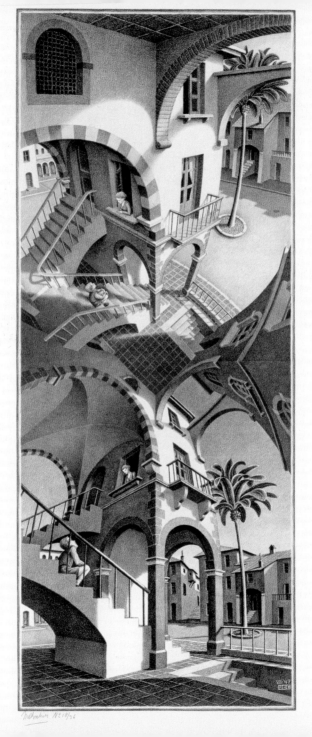

De Pedalternorotandomovens centroculatus articulosus ontstond,(generatio spontanea!) uit onbevredigdheid over het in de natuur ontbreken van wielvormige,levende schepselen met het vermogen zich rollend voort te bewegen.Het hierbij afgebeelde diertje,in de volksmond genaamd „wentelteefje"of „rolpens", tracht dus in een diepgevoelde behoefte te voorzien.Biologische bijzonderheden zijn nog schaars :is het een zoogdier,een reptiel,of een insekt?Het heeft een langgerekt,uit verhoornde geledingen gevormd lichaam en drie paren poten,waarvan de uiteinden gelijkenis vertonen met de menselijke voet. In het midden van de dikke,ronde kop,die voorzien is van een sterk gebogen papagaaiensnavel,bevinden zich de bolvormige ogen,die,op stelen geplaatst,ter weerszijden van de kop ver uitsteken.In gestrekte positie kan het dier zich,traag en bedachtzaam,door middel van zijn zes poten,voort bewegen over een willekeurig substraat (het kan eventueel steile trappen opklimmen of afdalen ,door struikgewas heendringen of over rotsblokken klauteren).Zodra het echter een lange weg moet afleggen

en daartoe een betrekkelijk vlakke baan tot zijn beschikking heeft,drukt het zijn kop op de grond en rolt zich bliksemsnel op,waarbij het zich afduwt met zijn poten voor zoveel deze dan nog de grond raken.In opgerolde toestand vertoont het de gedaante van een discus-schijf, waarvan de centrale as gevormd wordt door de ogen-op-stelen.Door zich beurtelings af te zetten met één van zijn drie paren poten,kan het een grote snelheid bereiken. Ook trekt het naar believen tijdens het rollen(b.v.bij het afdalen van een helling,of om zijn vaart uit te lopen)de poten in en gaat „freewheelende"verder.Wanneer het er aanleiding toe heeft,kan het op twee wijzen weer in wandel-positie overgaan: ten eerste abrupt,door zijn lichaam plotseling te strekken,maar dan ligt het op zijn rug,met zijn poten in de lucht en ten tweede door geleidelijke snelheidsvermindering (remming met de poten) en langzame achterwaartse ontrolling in stilstaande toestand.

XI-'51

MCEscher Profschrift

164 Up and Down. 165 Curl-up.
En haut et en bas. Pelote.
Oben und Unten. Krempeltierchen.

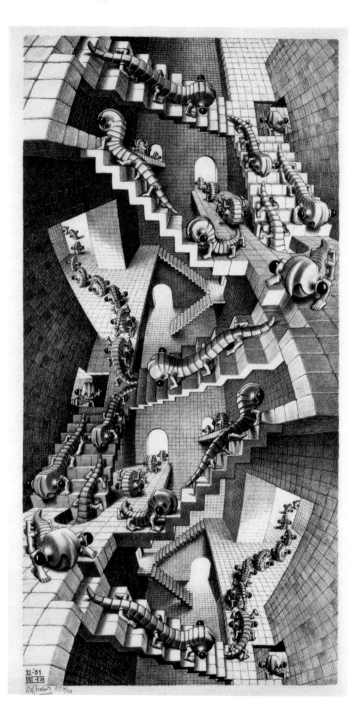

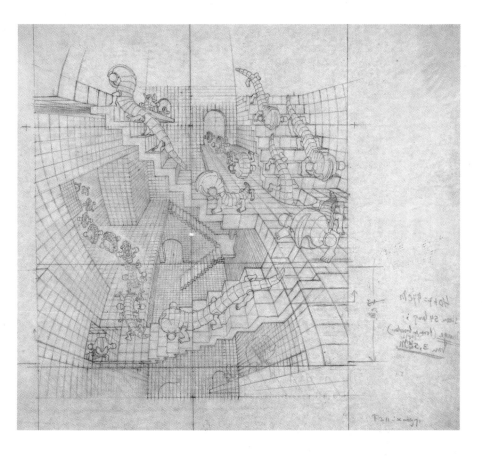

166 House of Stairs. 167 [study for House of Stairs].
 Maison d'escaliers. [Étude pour Maison d'escaliers].
 Treppenhaus. [Studie für Treppenhaus].

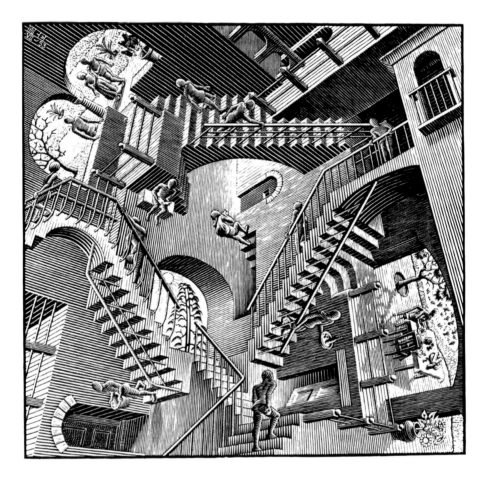

Relativity.
Relativité.
Relativität.

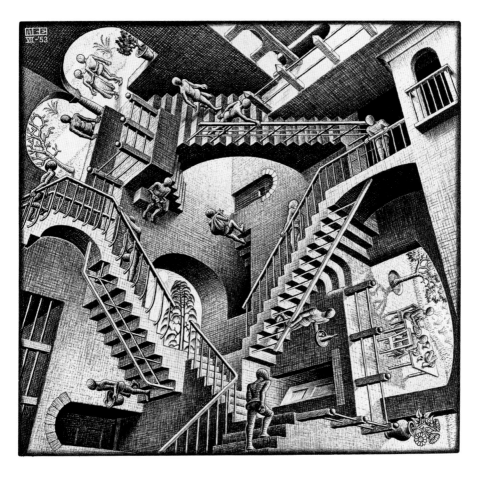

Relativity.
Relativité.
Relativität.

CONFLICT FLAT-SPATIAL
CONFLIT ENTRE PLAN ET ESPACE
KONFLIKT ZWISCHEN FLÄCHE UND RAUM

Three Spheres I.
Trois sphères I.
Drei Kugeln I.

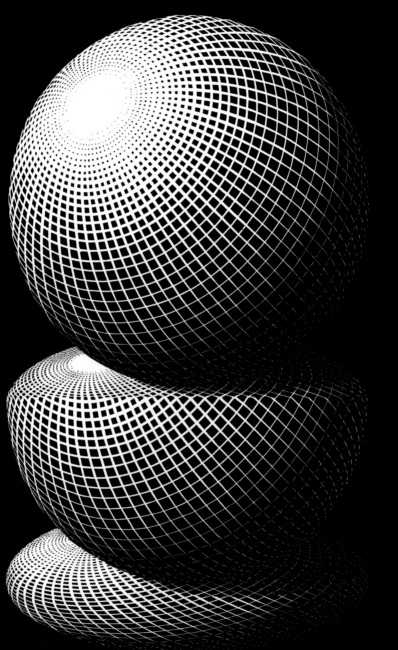

IX-45

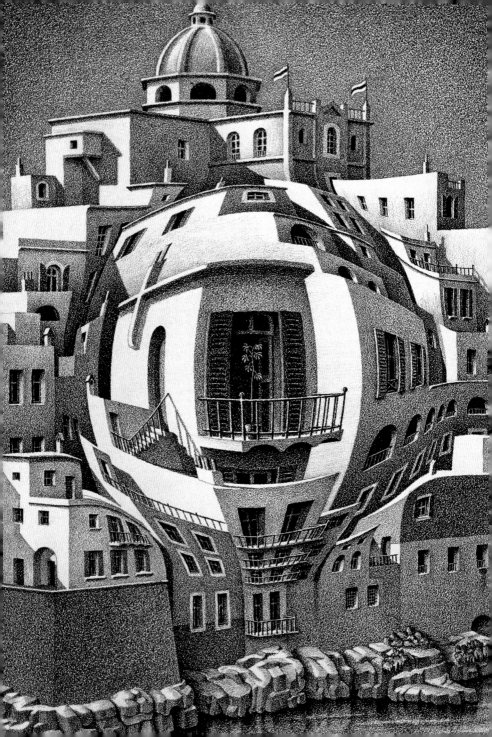

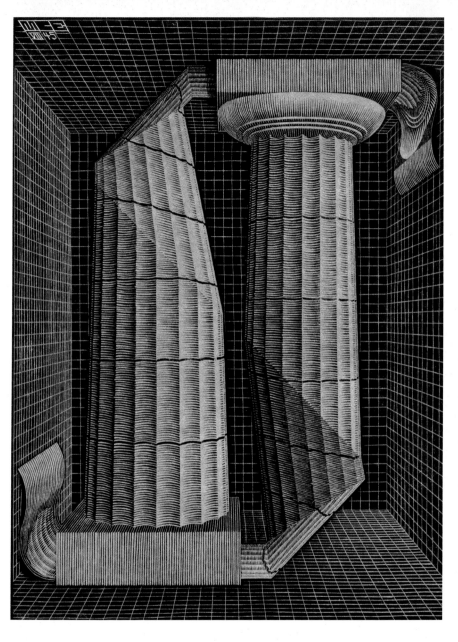

172 Balcony.
Balcon.
Balkon.

173 (Two) Doric Columns.
(Deux) Colonnes doriques.
(Zwei) Dorische Säulen.

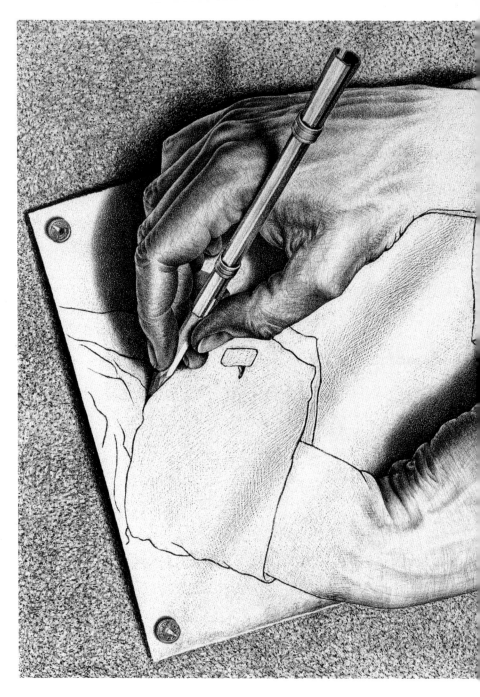

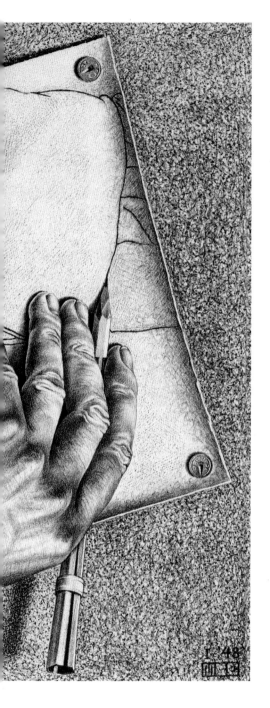

Drawing Hands.
Mains qui dessinent.
Zeichnende Hände.

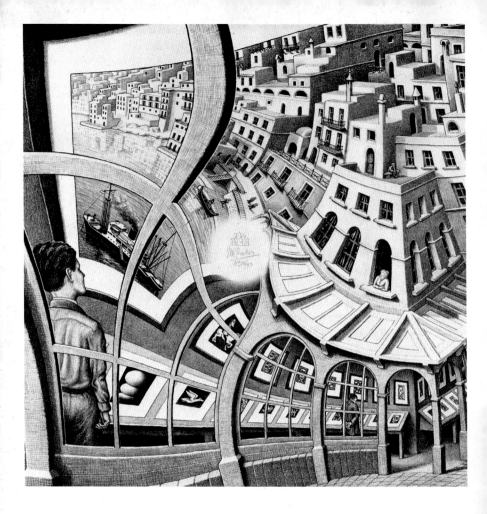

176 Print Gallery.
 Galerie de gravures.
 Druckgalerie.

177 Dragon.
 Dragon.
 Drachen.

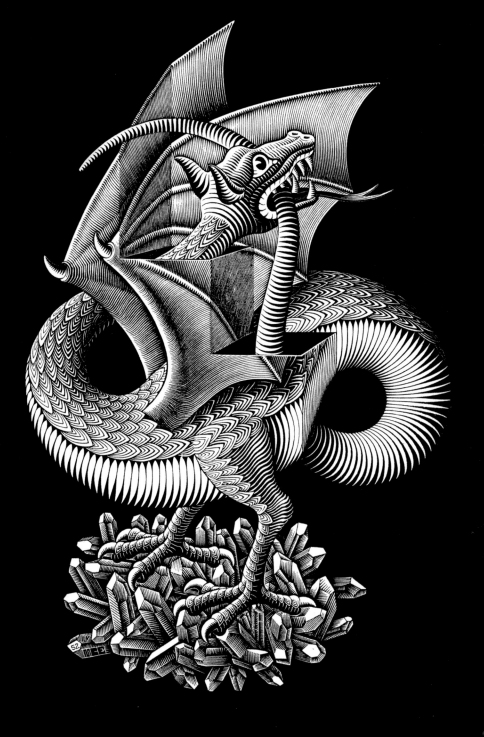

IMPOSSIBLE BUILDINGS
CONSTRUCTIONS IMPOSSIBLES
UNMÖGLICHE BAUWERKE

Belvedere.
Belvédère.
Belvedere.

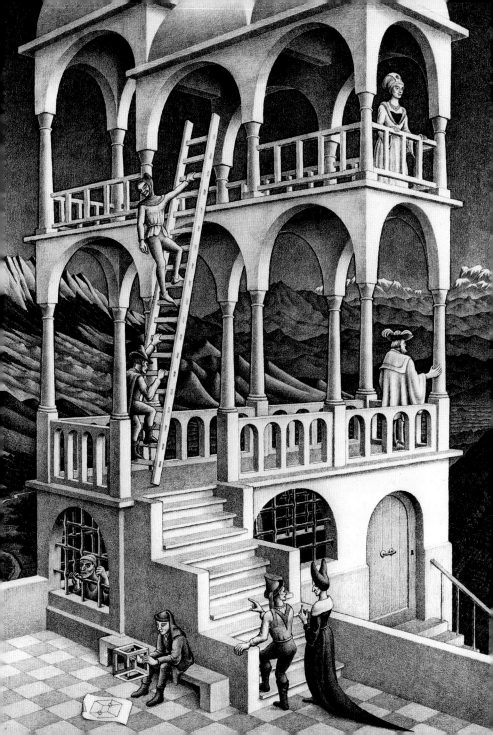

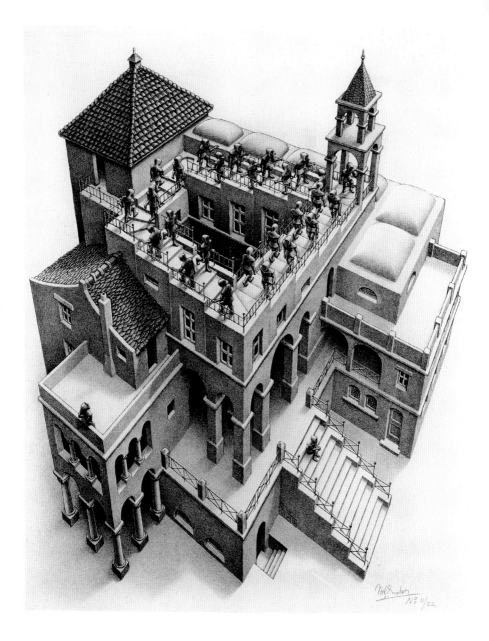

Ascending and Descending.
Montée et descente.
Treppauf, Treppab.

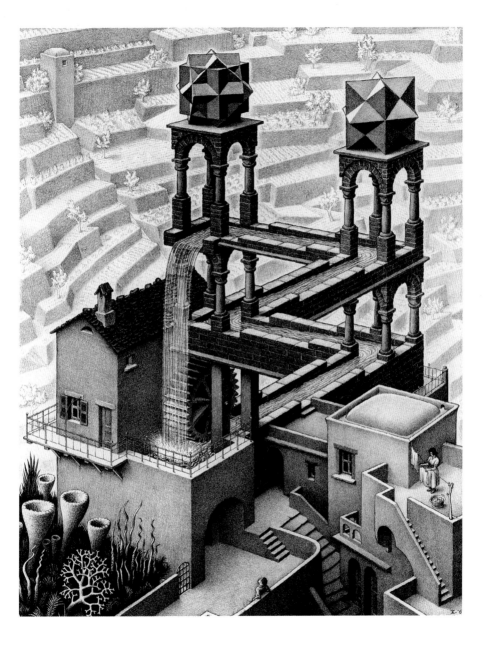

Waterfall.

Chute d'eau.

Wasserfall.

INDEX

October 1922.
 Mosaïque murale à l'Alhambra. Dessin, 20 octobre 1922.
 Mosaikwand in der Alhambra; Zeichnung, 20. Oktober 1922.

50 | 51
 Metamorphosis [I]. May 1937. Woodcut, printed on two sheets.
 Métamorphose [I]. Mai 1937. Gravure sur bois de fil, imprimée sur deux feuilles.
 Metamorphose [I]. Mai 1937. Holzschnitt, auf zwei Platten gedruckt.
 195 x 908 mm (7,625 x 35,75'').

52 | 53
 Day and Night. February 1938. Woodcut in black and grey, printed from two blocks.
 Jour et nuit. Février 1938. Gravure sur bois de fil en noir et gris, imprimée à partir de deux planches.
 Tag und Nacht. Februar 1938. Holzschnitt in Schwarz und Grau, von zwei Blöcken gedruckt.
 391 x 677 mm (15,375 x 26,625'').

54
 Development I. November 1937. Woodcut.
 Développement I. Novembre 1937. Gravure sur bois.
 Entwicklung I. November 1937. Holzschnitt.
 437 x 446 mm (17,25 x 17,5'').

55
 Cycle. May 1938. Lithograph.
 Cycle. Mai 1938. Lithographie.
 Zyklus. Mai 1938. Lithografie.
 475 x 279 mm (18,75 x 11'').

56
 Sky and Water I. June 1938. Woodcut.
 Ciel et eau I. Juin 1938. Gravure sur bois de fil.
 Himmel und Wasser I. Juni 1938. Holzschnitt.
 435 x 439 mm (17,125 x 17,25'').

57
 Sky and Water II. December 1938. Woodcut.
 Ciel et eau II. Décembre 1938. Gravure sur bois.

Himmel und Wasser II. Dezember 1938. Holzschnitt.
 623 x 407 mm (24,5 x 16'').

58
 Verbum (Earth, Sky and Water). July 1942. Lithograph, second state.
 Verbum (Terre, ciel et eau). Juillet 1942. Lithographie, second état.
 Verbum (Erde, Himmel und Wasser). Juli 1942. Lithografie, zweite Version.
 332 x 386 mm (13,125 x 15,25'').

59
 Encounter. May 1944. Lithograph.
 Rencontre. Mai 1944. Lithographie.
 Begegnung. Mai 1944. Lithografie.
 342 x 464 mm (13,5 x 18,25'').

60 | 61
 Reptiles. March 1943. Lithograph.
 Reptiles. Mars 1943. Lithographie.
 Reptilien. März 1943. Lithografie.
 334 x 385 mm (13,125 x 15,125'').

62 | 63
 Magic Mirror. January 1946. Lithograph.
 Miroir magique. Janvier 1946. Lithographie.
 Der Zauberspiegel. Januar 1946. Lithografie.
 280 x 445 mm (11 x 17,5'').

64 | 65
 Horseman. July 1946. Woodcut in red, black and grey, printed from three blocks.
 Cavaliers. Juillet 1946. Gravure sur bois de fil en rouge, noir et gris, imprimée à partir de trois planches.
 Reiter. Juli 1946. Holzschnitt in Rot, Schwarz und Grau, von drei Blöcken gedruckt.
 239 x 449 mm (9,375 x 17,625'').

66
 Sun and Moon. April 1948. Woodcut in blue, red, yellow and black, printed from four blocks.
 Soleil et lune. Avril 1948. Gravure sur bois de fil en bleu, rouge, jaune et noire, imprimée à partir de quatre planches.
 Sonne und Mond. April 1948. Holzschnitt in Blau, Rot, Gelb und Schwarz, von vier Blöcken

gedruckt.
 251 x 270 mm (9,875 x 10,625'').

67
 Two Intersecting Planes. January 1952. Woodcut in green, brown and black, printed from three blocks.
 Deux plans sécants. Janvier 1952. Gravure sur bois de fil en vert, marron et noir, imprimée à partir de trois planches.
 Zwei sich schneidende Flächen. Januar 1952. Holzschnitt in Grün, Braun und Schwarz, von drei Blöcken gedruckt.
 224 x 310 mm (8,875 x 12,25'').

68 | 69
 Swans (White Swans, Black Swans). February 1956. Wood engraving.
 Les cygnes (Cygnes blancs, cygnes noirs). Février 1956. Gravure sur bois de bout.
 Schwäne (Weiße Schwäne, Schwarze Schwäne). Februar 1956. Holzstich.
 199 x 319 mm (7,875 x 12,5'').

70
 Design drawing for intarsia wood panels with fish for Leiden Stadhuis, July 1940. Watercolor, gouache.
 Dessin pour des panneaux de bois intarsia avec des poissons pour Leiden Stadhuis, juillet 1940. Aquarelle, gouache.
 Zeichenentwurf für Intarsien mit Fischen für das Stadhuis in Leiden, Juli 1940. Wasserfarben, Gouache.
 548 x 665 mm (20 x 26,125'').

71
 [Regular Division of the Plane IV]. June 1957. Woodcut in red.
 [Division régulière du plan IV]. Juin 1957. Gravure sur bois de fil en rouge.
 [Regelmäßige Flächenaufteilung IV]. Juni 1957. Holzschnitt in Rot.
 240 x 180 mm (9,5 x 7,125'').

72
 Development II. February 1939. Woodcut in brown, grey-green and black, printed from three blocks.
 Développement II. Février 1939. Gravure sur bois de fil en marron, vert-gris et noir,

Imprimée à partir de trois planches.

Entwicklung II. Februar 1939. Holzschnitt in Braun, Grau-Grün und Schwarz, von drei Blöcken gedruckt.
455 x 455 mm (17,875 x 17,875'').

73

Division. July 1956. Woodcut, second state. Diameter 375 mm (14,75'').

Division. Juillet 1956. Gravure sur bois de fil, second état. Diamètre : 375 mm (14,75'').

Division. Juli 1956. Holzschnitt, zweite Version. Durchmesser 375 mm (14,75'').

74

Smaller and Smaller. October 1956. Wood engraving and woodcut in black and brown, printed from four blocks.

De plus en plus petit. Octobre 1956. Gravure sur bois de bout et sur bois de fil en noir et marron, imprimée à partir de quatre planches.

Kleiner und Kleiner. Oktober 1956. Holzstich und Holzschnitt in Schwarz und Braun, von vier Blöcken gedruckt.
380 x 380 mm (15 x 15'').

75

Square Limit. April 1954. Woodcut in red and grey-green, printed from two blocks.

Limite carrée. Avril 1954. Gravure sur bois de fil en rouge et gris-vert, imprimée à partir de deux planches.

Quadratlimit. April 1954. Holzschnitt in Rot und Grau-Grün, von zwei Blöcken gedruckt.
340 x 340 mm (13,375 x 13,375'').

76

[Butterflies]. Drawn at Baarn, October 1950. coloured drawing, an 'inverted circle limit'.

[Papillons]. Dessiné à Baarn, octobre 1950. Dessin en couleur d'un « limite circulaire inversée ».

[Schmetterlinge]. Gezeichnet in Baarn, Oktober 1950. Farbzeichnung, ein "umgekehrtes Kreislimit".

77

Design drawing for ceiling for Demonstration Laboratory, Philips Company, Eindhoven, 1951. Pencil, watercolor, india ink.

Dessin pour le plafond du laboratoire de démonstration, entreprise Philips, Eindhoven, 1951. Crayon, aquarelle, encre indienne.

Zeichenentwurf für die Decke des Demonstrationslabors für das Unternehmen Philips, Eindhoven, 1951. Bleistift, Wasserfarben, Tusche.

78

Circle Limit III. December 1959. Woodcut, second state, in yellow, green, blue, brown and black, printed from five blocks. Diameter 415 mm (16,375'').

Limite circulaire III. Décembre 1959. Gravure sur bois de fil, second état, en jaune, vert, bleu, marron et noir, imprimée à partir de cinq planches. Diamètre : 415 mm (16,375'').

Kreislimit III. Dezember 1959. Holzschnitt, zweite Version, in Gelb, Grün, Blau, Braun und Schwarz, von fünf Blöcken gedruckt. Durchmesser 415 mm (16,375'').

79

Circle Limit IV (Heaven and Hell). July 1960. Woodcut in black and ochre, printed from two blocks. Diameter 416 mm (16,375'').

Limite circulaire IV (Enfer et paradis). Juillet 1960. Gravure sur bois de fil en noir et ocre, imprimée à partir de deux planches. Diamètre : 416 mm (16,375'').

Kreislimit IV (Himmel und Hölle). Juli 1960. Holzschnitt in Schwarz und Ocker, von zwei Blöcken gedruckt. Durchmesser 416 mm (16,375'').

80

Snakes. July 1969. Woodcut in orange, green and black, printed from three blocks.

Serpents. Juillet 1969. Gravure sur bois de fil en orange, vert et noir, imprimée à partir de trois planches.

Schlangen. Juli 1969. Holzschnitt in Orange, Grün und Schwarz, von drei Blöcken gedruckt.
498 x 447 mm (19,625 x 17,625'').

81

Sphere Surface with Fish. July 1958. Woodcut in grey, gold and reddish brown, printed from three blocks.

Surface sphérique avec poisson. Juillet 1958. Gravure sur bois de fil en gris, or et marron-rouge, imprimée à partir de trois planches.

Kugeloberfläche mit Fischen. Juli 1958. Holzschnitt in Grau, Gold und Rot-Braun, von drei Blöcken gedruckt.
340 x 340 mm (13,375 x 13,375'').

82

Carved sphere with fish. 1940. Beechwood, stained in four colors. Diameter 140 mm (5,5'').

Sphère gravée avec poisson. 1940. Bois de hêtre, teinté de quatre couleurs. Diamètre : 140 mm (5,5'').

Geschnitzte Kugel mit Fisch. 1940.

Buchenholz, mit vier Farben bemalt. Durchmesser 140 mm (5,5'').

83

The tin designed by Escher in 1963 for the Verblifa Company. Diameter 170 mm (6,75'').

Boîte métallique créée par Escher en 1963 pour l'entreprise Verblifa. Diamètre : 170 mm (6,75'').

Die Dose, die Escher 1963 für das Unternehmen Verblifa entwarf. Durchmesser 170 mm (6,75'').

84

Whirlpools. November 1957. Wood engraving and woodcut, second state, in red, grey and black, printed from two blocks.

Tourbillons. Novembre 1957. Gravure sur bois de bout et sur bois de fil, second état, en rouge, gris et noir, imprimée à partir de deux planches.

Strudel. November 1957. Holzstich und Holzschnitt, zweite Version, in Rot, Grau und Schwarz, von zwei Blöcken gedruckt.
438 x 235 mm (17,25 x 9,25'').

85

Escher no. 101 [Lizards]. September 1956. India ink, pencil, watercolor. 295 x 145 mm (image) (11,625 x 5,75''); 304 x 227 mm (sheet) (11,875 x 9'').

Escher n° 101 [Lézards]. Septembre 1956. Encre indienne, crayon, aquarelle. Image : 295 x 145 mm (11,625 x 5,75'') ; feuille : 304 x 227 mm (11,875 x 9'').

Escher Nr. 101 [Eidechsen]. September 1956. Tusche, Bleistift, Wasserfarben. 295 x 145 mm (11,625 x 5,75'') (Bild); 304 x 227 mm (11,875 x 9'') (Platte).

86

Plane Filling I. March 1951. Mezzotint.

Remplissage du plan I. Mars 1951. Mezzo-tinto.

Flächenfüllung I. März 1951. Mezzotint.
146 x 192 mm (5,75 x 7,75'').

87

Plane Filling II. July 1957. Lithograph.

Remplissage du plan II. Juillet 1957. Lithographie.

Flächenfüllung II. Juli 1957. Lithografie.
315 x 370 mm (12,375 x 14,625'').

88

[Fish]. Woodcut printed on textile, c. 1942.

[Poisson]. Gravure sur bois de fil imprimée sur tissu, c. 1942.

[Fisch]. Holzschnitt, auf Textil gedruckt, ca. 1942.
420 x 420 mm (16,5 x 16,5'').

89

Hand-printed design of fish on silk, 1943. Gold and black on red.

Dessin d'un poisson imprimé à la main sur soie, 1943. Or et noir sur rouge.

Handgedrucktes Design eines Fisches auf Seide, 1943. Gold und Schwarz auf Rot.
450 x 450 mm (17,75 x 17,75'').

90

Escher no. 20 [Fish]. Drawn at Ukkel, March 1938. India ink, pencil, watercolor, gold paint. 229 x 243 mm (image) (9 x 9,5''); 358 x 268 mm (sheet) (14 x 10,625'').

Escher n°. 20 [Poisson]. Dessiné à Ukkel, mars 1938. Encre indienne, crayon, aquarelle, peinture dorée. Image : 229 x 243 mm (9 x 9,5'') ; feuille : 358 x 268 mm (14 x 10,625'').

Escher Nr. 20 [Fisch]. Gezeichnet in Ukkel, März 1938. Tusche, Bleistift, Wasserfarben, Goldfarbe. 229 x 243 mm (9 x 9,5'') (Bild); 358 x 268 mm (14 x 10,625'') (Platte).

91

Escher no. 22 [Bird/Fish]. Drawn at Ukkel, June 1938. India ink, colored pencil, watercolor. 228 x 243 mm (image) (9 x 9,5''); 358 x 270 mm (sheet) (14 x 10,625'').

Escher n° 22 [Oiseau/Poisson]. Dessiné à Ukkel, juin 1938. Encre indienne, crayon de couleur, aquarelle. Image : 228 x 243 mm (9 x 9,5'') ; feuille : 358 x 270 mm (14 x 10,625'').

Escher Nr. 22 [Vogel/Fisch]. Gezeichnet in Ukkel, Juni 1938. Tusche, farbiger Bleistift, Wasserfarben. 228 x 243 mm (9 x 9,5'') (Bild); 358 x 270 mm (14 x 10,625'') (Platte).

92 | 93

Escher no. 58 [Two Fish]. Drawn at Baarn, November 1942. Watercolor, ink. 280 x 178 mm (image) (11 x 7''); 305 x 230 mm (sheet) (12 x 9'').

Escher n° 58 [Deux Poissons]. Dessiné à Baarn, novembre 1942. Aquarelle, encre. Image : 280 x 178 mm (11 x 7'') ; feuille : 305 x 230 mm (12 x 9'').

Escher Nr. 58 [Zwei Fische]. Gezeichnet in Baarn, November 1942. Wasserfarben, Tusche. 280 x 178 mm (11 x 7'') (Bild); 305 x 230 mm (12 x 9'') (Platte).

94

Periodic Design A1 [Bat]. [Rome, c. 1926]. Ink, transparent and metallic, printed in five colors on black satin. Wall hanging 1460 x 946 mm (57,5 x 37,25'').

Dessin Périodique A1 [Chauve-Souris]. [Rome, c. 1926]. Encre, transparente et métallisée. Impression dans cinq couleurs sur du satin noir. Décor mural de 1460 x 946 mm (57,5 x 37,25'').

Periodisches Design A1 [Fledermaus]. [Rom, ca. 1926]. Tusche, transparent und metallisch, in fünf Farben auf schwarzem Satin gedruckt. Wandbehang 1460 x 946 mm (57,5 x 37,25'').

95

Escher no. 45 [Angel-Devil]. Drawn at Baarn, Christmas 1941. India ink, colored pencil, opaque white. 245 x 239 mm (image) (9,5 x 9,375''); 359 x 270 mm (sheet) (14 x 10,625'').

Escher n° 45 [Ange-Démon]. Dessiné à Baarn, Noël 1941. Encre indienne, crayon de couleur, blanc opaque. Image : 245 x 239 mm (9,5 x 9,375'') ; feuille : 359 x 270 mm (14 x 10,625'').

Escher Nr. 45 [Engel-Teufel]. Gezeichnet in Baarn, Weihnachten 1941. Tusche, farbiger Bleistift, opakes Weiß. 245 x 239 mm (9,5 x 9,375'') (Bild); 359 x 270 mm (14 x 10,625'') (Platte).

96 | 97

Escher no. 66 [Winged Lion]. Drawn at Baarn, October 1945. Ink, watercolor. 173 x 280 mm (image) (6,75 x 11''); 305 x 230 mm (sheet) (12 x 9'').

Escher n° 66 [Le Lion Ailé]. Dessiné à Baarn, octobre 1945. Encre, aquarelle. Image : 173 x 280 mm (6,75 x 11'') ; feuille : 305 x 230 mm (12 x 9'').

Escher Nr. 66 [Geflügelter Löwe]. Gezeichnet in Baarn, Oktober 1945. Tinte, Wasserfarben. 173 x 280 mm (6,75 x 11'') (Bild); 305 x 230 mm (12 x 9'') (Platte).

98

Escher no. 55 [Fish]. Drawn at Baarn, November 1942. Ink, watercolor. 220 x 205 mm (image) (8,675 x 8'') ; 305 x 230 mm (sheet) (12 x 9'').

Escher n° 55 [Poisson]. Dessiné à Baarn, novembre 1942. Encre, aquarelle. Image : 220 x 205 mm (8,675 x 8'') ; feuille : 305 x 230 mm (12 x 9'').

Escher Nr. 55 [Fisch]. Gezeichnet in Baarn, November 1942. Tinte, Wasserfarben. 220 x 205 mm (8,675 x 8") (Bild); 305 x 230 mm (12 x 9'') (Platte).

99

Escher no. 85 [Lizard/Fish/Bat]. Drawn at Baarn, April 1952. Ink, pencil, watercolor. 270 x 212 mm (image) (10,675 x 8,375''); 305 x 230 mm (sheet) (12 x 9'').

Escher n° 85 [Lézard/Poisson/Chauve-Souris]. Dessiné à Baarn, avril 1952. Encre, crayon, aquarelle. Image : 270 x 212 mm (10,675 x 8,375'') ; feuille : 305 x 230 mm (12 x 9'').

Escher Nr. 85 [Eidechse/Fisch/Fledermaus]. Gezeichnet in Baarn, April 1952. Tinte, Bleistift, Wasserfarben. 270 x 212 mm (10,675 x 8,375'') (Bild); 305 x 230 mm (12 x 9'') (Platte).

100 | 101

Escher no. 69 [Fish/Duck/Lizard]. Drawn at Baarn, March 1948. Ink, watercolor. 275 x 208 mm (image) (10,875 x 8''); 305 x 325 mm (sheet) (12 x 13,75'').

Escher n° 69 [Poisson/Canard/Lézard]. Dessiné à Baarn, mars 1948. Encre, aquarelle. Image : 275 x 208 mm (10,875 x 8'') ; feuille : 305 x 325 mm (12 x 13,75'').

Escher Nr. 69 [Fisch/Ente/Eidechse]. Gezeichnet in Baarn, März 1948. Tinte, Wasserfarben. 275 x 208 mm (10,875 x 8'') (Bild); 305 x 325 mm (12 x 13,75'') (Platte).

102

Escher no. 46 [Two Fish]. Drawn at Baarn, May 1942. India ink, colored pencil, watercolor. 289 x 255 mm (image) (11,375 x 10''); 359 x 270 mm (sheet) (14,125 x 10,625'').

Escher n° 46 [Deux Poissons]. Dessiné à Baarn, mai 1942. Encre indienne, crayon de couleur, aquarelle. Image : 289 x 255 mm (11,375 x 10'') ; feuille : 359 x 270 mm (14,125 x 10,625'').

Escher Nr. 46 [Zwei Fische]. Gezeichnet in Baarn, Mai 1942. Tusche, farbiger Bleistift, Wasserfarben. 289 x 255 mm (11,375 x 10'') (Bild); 359 x 270 mm (14,125 x 10,625'') (Platte).

103

Escher no. 67 [Horseman]. Drawn at Baarn, June 1946. India ink, colored pencil, watercolor. 213 x 214 mm (image) (8 ,375x 8,375''); 304 x 228 mm (sheet) (12 x 9'').

Escher n° 67 [Cavalier]. Dessiné à Baarn, juin 1946. Encre indienne, crayon de couleur, aquarelle. Image : 213 x 214 mm (8 ,375x 8,375'') ; feuille : 304 x 228 mm (12 x 9'').

Escher Nr. 67 [Reiter]. Gezeichnet in Baarn, Juni 1946. Tusche, farbiger Bleistift, Wasserfarben. 213 x 214 mm (8 ,375x 8,375'') (Bild); 304 x 228 mm (12 x 9") (Platte).

104

Escher no. 102 [Ray Fish]. Drawn at Baarn, March 1958. Ink. 200 x 200 mm (image) (7 ,875x 7,875''); 305 x 230 mm (sheet) (12 x 9,125'').

Escher n° 102 [Raie]. Dessiné à Baarn, mars 1958. Encre. Image : 200 x 200 mm (7 ,875x 7,875'') ; feuille : 305 x 230 mm (12 x 9,125'').

Escher Nr. 102 [Rochen]. Gezeichnet in Baarn, März 1958. Tinte. 200 x 200 mm (7 ,875 x 7,875'') (Bild); 305 x 230 mm (12 x 9,125'') (Platte).

105

Escher no. 103 [Fish]. Drawn at Baarn, April 1959. India ink, colored ink, pencil, watercolor. 221 x 206 mm (image) (8,625 x 8,125''); 304 x 227 mm (sheet) (12 x 9'').

Escher n° 103 [Poisson]. Dessiné à Baarn, avril 1959. Encre indienne, encre de couleur, crayon, aquarelle. Image : 221 x 206 mm (8,625 x 8,125'') ; feuille : 304 x 227 mm (12 x 9'').

Escher Nr. 103 [Fisch]. Gezeichnet in Baarn, April 1959. Tusche, farbige Tinte, Bleistift, Wasserfarben. 221 x 206 mm (8,625 x 8,125'') (Bild); 304 x 227 mm (12 x 9'') (Platte).

106 I 107

Escher no. 130 [Fish/Horse]. Drawn at Baarn, July 1967. Ink. 192 x 233 mm (image) (7,5 x 9,125''); 270 x 358 mm (sheet) (10,625 x 14'').

Escher n° 130 [Poisson/Cheval]. Dessiné à Baarn, juillet 1967. Encre. Image : 192 x 233 mm (7,5 x 9,125'') ; feuille : 270 x 358 mm (10,625 x 14'' x 14'').

Escher Nr. 130 [Fisch/Pferd]. Gezeichnet in Baarn, Juli 1967. Tinte. 192 x 233 mm (7,5 x 9,125'') (Bild); 270 x 358 mm (10,625 x 14'') (Platte).

108

Escher no. 107 [Fish]. Drawn at Baarn, December 1960. Ink, watercolor. 200 x 200 mm (image) (7,875 x 7,875''); 305 x 230 mm (sheet) (12 x 9'').

Escher n° 107 [Poisson]. Dessiné à Baarn, décembre 1960. Encre, aquarelle. Image : 200 x 200 mm (7,875 x 7,875'') ; feuille : 305 x 230 mm (12 x 9'').

Escher Nr. 107 [Fisch]. Gezeichnet in Baarn, Dezember 1960. Tinte, Wasserfarben. 200 x 200 mm (7,875 x 7,875'') (Bild); 305 x 230 mm (12 x 9'') (Platte).

109

Escher no. 109 [Creeping Creature]. Drawn at Baarn, January 1961. Chalk, ink, watercolor. 201 x 202 mm (image) (7,875 x 8''); 301 x 230 mm (sheet) (11,75 x 9'').

Escher n° 109 [Créature Rampante]. Dessiné à Baarn, janvier 1961. Craie, encre, aquarelle. Image : 201 x 202 mm (7,875 x 8'') ; feuille : 301 x 230 mm (11,75 x 9'').

Escher Nr. 109 [Kriechende Kreatur]. Gezeichnet in Baarn, Januar 1961. Kreide, Tinte, Wasserfarben. 201 x 202 mm (7,875 x 8'') (Bild); 301 x 230 mm (11,75 x 9'') (Platte).

110 I 111

Escher no. 115 [Flying Fish/Bird]. Drawn at Baarn, March 1963. Ink, watercolor. 198 x 198 mm (image) (7,875 x 7,975''); 305 x 230 mm (sheet) (12 x 9'').

Escher n° 115 [Poisson Volant/Oiseau]. Dessiné à Baarn, mars 1963. Encre, aquarelle. Image : 198 x 198 mm (7,875 x 7,975'') ; feuille : 305 x 230 mm (12 x 9'').

Escher Nr. 115 [Fliegender Fisch/Vogel]. Gezeichnet in Baarn, März 1963. Tinte, Wasserfarben. 198 x 198 mm (7,875 x 7,975'') (Bild); 305 x 230 mm (12 x 9'') (Platte).

112

Design for tiled facade for the entrance of a school in The Hague. December 1959. Cast concrete tiles in two colours. 5 x 14 m (196,75 x 551,75'') (aprox.).

Création pour la façade en mosaïque de l'entrée de l'école de La Haye. Décembre 1959. Mosaïque en béton coulé de deux couleurs. 5 x 14 mètres environ (196,75 x 551,75'').

Entwurf einer Kachelfassade für den Eingang einer Schule in Den Haag. Dezember 1959. Betonkacheln in zwei Farben. 5 x 14 Meter (ca.) (196,75 x 551,75'').

113

Escher no. 105 [Pegasus]. Drawn at Baarn, June 1959. India ink, pencil, watercolor. 205 x 205 mm (image) (8 x 8''); 303 x 230 mm (sheet) (12 x 9'').

Escher n° 105 [Pégase]. Dessiné à Baarn, juin 1959. Encre indienne, crayon, aquarelle. Image : 205 x 205 mm (8 x 8'') ; feuille : 303 x 230 mm (12 x 9'').

Escher Nr. 105 [Pegasus]. Gezeichnet in Baarn, Juni 1959. Tusche, Bleistift, Wasserfarben. 205 x 205 mm (8 x 8'') (Bild); 303 x 230 mm (12 x 9'') (Platte).

114-121

Metamorphosis III. 1967-68. Woodcut,

second state, in black, green and reddish brown, printed from thirty-three blocks on six combined sheets, mounted on canvas; partly coloured by hand.

Métamorphose III. 1967-68. Gravure sur bois de fil, second état, en noir, vert et marron-rouge, imprimée à partir de trente-trois planches sur six feuilles combinées et montées sur canevas, puis en partie colorée à la main.

Metamorphose III. 1967-68. Holzschnitt, zweite Version, in Schwarz, Grün und Rot-Braun, von 33 Blöcken auf sechs kombinierten Platten, auf Leinwand aufgezogen; teilweise handgefärbt. 192 x 6800 mm (7,5 x 268'').

123

Depth. October 1955. Wood engraving and woodcut in brown-red, grey-green and dark brown, printed from three blocks.

Profondeur. Octobre 1955. Gravure sur bois de bout et sur bois de fil en marron-rouge, gris-vert et marron foncé, imprimée à partir de trois planches.

Tiefe. Oktober 1955. Holzstich und Holzschnitt in Braun-Rot, Grau-Grün und Dunkelbraun, von drei Blöcken gedruckt. 320 x 230 mm (12,625 x 9'').

124 I 125

Cubic Space Division (Cubic Space Filling). December 1952. Lithograph.

Division d'espace cubique (Remplissage d'espace cubique). Décembre 1952. Lithographie.

Kubische Raumaufteilung (Kubische Raumfüllung). Dezember 1952. Lithografie. 266 x 266 mm (10,5 x 10,5'').

127

Knots. August 1965. Woodcut in black, green and brown, printed from three blocks.

Nœuds. Août 1965. Gravure sur bois de fil en noir, vert et marron, imprimée à partir de trois planches.

Knoten. August 1965. Holzschnitt in Schwarz, Grün und Braun, von drei Blöcken gedruckt. 430 x 320 mm (16,875 x 12,625'').

128

[Study for Knot]. Canada July 1966. [Étude pour Nœuds]. Canada, juillet 1966. [Studie für Knoten]. Kanada, Juli 1966. 371 x 341 mm (14,625 x 13,375'').

129

Concentric Rinds (Concentric Space Filling/Regular Sphere Division). May 1953.

Wood engraving.
Écorces concentriques (Remplissage d'espace concentrique/Division de sphère régulière). Mai 1953. Gravure sur bois de fil.
Konzentrische Schalen (Konzentrische Flächenteilung/Gleichmäßige Kugelteilung). Mai 1953. Holzstich.
241 x 241 mm (9,5 x 9,5'').

130
Spirals. December 1953. Wood engraving in black and grey, printed from two blocks.
Spirales. Décembre 1953. Gravure sur bois de bout en noir et gris, imprimée à partir de deux planches.
Spiralen. Dezember 1953. Holzstich in Schwarz und Grau, von zwei Blöcken gedruckt.
270 x 333 mm (10,625 x 13,125'').

131
Sphere Spirals. October 1958. Woodcut in grey, black, yellow and pink, printed from four blocks. Diameter 320 mm (12,625'').
Spirales sphériques. Octobre 1958. Gravure sur bois de fil en gris, noir, jaune et rose, imprimée à partir de quatre planches. Diamètre : 320 mm (12,625'').
Kugelspiralen. Oktober 1958. Holzschnitt in Grau, Schwarz, Gelb und Pink, von vier Blöcken gedruckt. Durchmesser 320 mm (12,625'').

132
Möbius Strip I. March 1961. Wood engraving and woodcut in red, green, gold and black, printed from four blocks.
Le ruban de Möbius I. Mars 1961. Gravure sur bois de bout et sur bois de fil en rouge, vert, or et noir, imprimée à partir de quatre planches.
Möbiusband I. März 1961. Holzstich und Holzschnitt in Rot, Grün, Gold und Schwarz, von vier Blöcken gedruckt.
238 x 259 mm (9,375 x 10,25'').

133
Möbius Strip II (Red Ants). February 1963. Woodcut in red, black and grey-green, printed from three blocks.
Le ruban de Möbius II (Fourmis rouges). Février 1963. Gravure sur bois de fil en rouge, noir et gris-vert, imprimée à partir de trois planches.
Möbiusband II (Rote Ameisen). Februar 1963. Holzschnitt in Rot, Schwarz und Grau-Grün, von drei Blöcken gedruckt.
453 x 205 mm (17,875 x 8,125'').

134
[Study for Rind]. May 1954. Wood engraving.
[Étude pour Pelure]. Mai 1954. Gravure sur bois de bout.
[Studie für Schale]. Mai 1954. Holzstich.
305 x 210 mm (12 x 8,25'').

135
Rind. May 1955. Wood engraving and woodcut in black, brown, blue-grey and grey, printed from four blocks.
Pelure. Mai 1955. Gravure sur bois de bout et sur bois de fil en noir, marron, bleu-gris et gris, imprimée à partir de quatre planches.
Schale. Mai 1955. Holzstich und Holzschnitt in Schwarz, Braun, Blau-Grau und Grau, von vier Blöcken gedruckt.
345 x 235 mm (13,625 x 9,25'').

136 | 137
Bond of Union. April 1956. Lithograph.
Connexion d'union. Avril 1956. Lithographie.
Band ohne Ende. April 1956. Lithografie.
253 x 339 mm (10 x 13,375'').

139 / Cover
Hand with Reflecting Sphere (Self-Portrait in Spherical Mirror). January 1935. Lithograph.
Main au globe (Autoportrait dans un miroir sphérique). Janvier 1935. Lithographie.
Hand mit reflektierender Kugel (Selbstporträt in kugelförmigem Spiegel). Januar 1935. Lithografie.
318 x 213 mm (12,5 x 8,375'').

140
Still Life with Mirror. March 1934. Lithograph.
Nature morte au miroir. Mars 1934. Lithographie.
Stillleben mit Spiegel. März 1934. Lithografie.
394 x 287 mm (15,5 x 11,25'').

141
Still Life with Spherical Mirror. November 1934. Lithograph.
Nature morte au miroir sphérique. Novembre 1934. Lithographie.
Stillleben mit Kugelförmigen Spiegel. November 1934. Lithografie.
286 x 326 mm (11,25 x 12,875'').

142 | 143
Three Spheres II. April 1946. Lithograph.
Trois sphères II. Avril 1946. Lithographie.
Drei Kugeln II. April 1946. Lithografie.

269 x 463 mm (10,625 x 18,25'').

144
Rippled Surface. March 1950. Linoleum cut in black and grey-brown, printed from two blocks.
Surface ondulée. Mars 1950. Linogravure en noir et gris-marron, imprimée à partir de deux planches.
Gewellte Oberfläche. März 1950. Linoleumschnitt in Schwarz und Grau-Braun, von zwei Blöcken gedruckt.
260 x 320 mm (10,25 x 12,625'').

145
Puddle. February 1952. Woodcut in black, green and brown, printed from three blocks.
Flaque d'eau. Février 1952. Gravure sur bois de fil en noir, vert et marron, imprimée à partir de trois planches.
Pfütze. Februar 1952. Holzschnitt in Schwarz, Grün und Braun, von drei Blöcken gedruckt.
240 x 319 mm (9,5 x 12,5'').

146
Three Worlds. December 1955. Lithograph.
Trois mondes. Décembre 1955. Lithographie.
Drei Welten. Dezember 1955. Lithografie.
362 x 247 mm (14,25 x 9,75'').

147
Drop (Dewdrop). February 1948. Mezzotint.
Goutte (Goutte de rosée). Février 1948. Mezzo-tinto.
Tropfen (Tautropfen). Februar 1948. Mezzotint.
179 x 245 mm (7 x 9,625'').

148 | 149
Eye. October 1946. Mezzotint, seventh and final state.
Œil. Octobre 1946. Mezzo-tinto, septième et dernier état.
Auge. Oktober 1946. Mezzotint, siebte und finale Version.
141 x 198 mm (5,5 x 7,75'').

151
Cube with Ribbons. February 1957. Lithograph.
Cube aux rubans. Février 1957. Lithographie.
Würfel mit magischen Bändern. Februar 1957. Lithografie.
309 x 305 mm (12,125 x 12'').

152 | 153
Convex and Concave. March 1955.
Lithograph.
Convexe et concave. Mars 1955.
Lithographie.
Konkav und Konvex. März 1955.
Lithografie.
275 x 335 mm (10,875 x 13,25'').

155
Stars. October 1948. Wood engraving.
Étoiles. Octobre 1948. Gravure sur bois de
bout.
Sterne. Oktober 1948. Holzstich.
320 x 260 mm (12,625 x 10,25'').

156
[Study for Stars]. August 1948. Woodcut.
[Étude pour Étoiles]. Août 1948. Gravure
sur bois de fil.
[Studie für Sterne]. August 1948.
Holzschnitt.
370 x 375 mm (14,625 x 14,75'').

157
Double Planetoid (Double Planet).
December 1949. Wood engraving in green, dark
blue, black and white, printed from four blocks,
second state. Diameter 374 mm (14,75'').
Double planétoïde. Décembre 1949.
Gravure sur bois de bout en vert, bleu foncé, noir
et blanc, imprimée à partir de quatre planches,
second état. Diamètre : 374 mm (14,75'').
Doppelplanetoid (Doppelplanet).
Dezember 1949. Holzstich in Grün, Dunkelblau,
Schwarz und Weiß, von vier Blöcken gedruckt,
zweite Version. Durchmesser 374 mm (14,75'').

158
Contrast (Order and Chaos). February
1950. Lithograph.
Contraste (Ordre et chaos). Février 1950.
Lithographie.
Kontrast (Ordnung und Chaos). Februar
1950. Lithografie.
280 x 280 mm (11 x 11'').

159
Gravity. June 1952. Lithograph and
watercolour.
Gravité. Juin 1952. Lithographie et
aquarelle.
Schwerkraft. Juni 1952. Lithografie und
Wasserfarben.
297 x 297 mm (11,75 x 11,75'').

160
Tetrahedral Planetoid (Tetrahedral

Planet). April 1954. Woodcut in green and
black, printed from two blocks.
Planétoïde tétraédrique. Avril 1954.
Gravure sur bois de fil en vert et noir, imprimée à
partir de deux planches.
Vierflächenplanetoid (Vierflächenplanet).
April 1954. Holzschnitt in Grün und Schwarz,
von zwei Blöcken gedruckt.
430 x 430 mm (16,875 x 16,875'').

161
Flatworms. January 1959. Lithograph.
Vers plats. Janvier 1959. Lithographie.
Plattwürmer. Januar 1959. Lithografie.
338 x 412 mm (13,25 x 16,25'').

163
Other World. January 1947. Wood engraving
and woodcut in black, reddish brown and green,
printed from three blocks.
L'autre monde. Janvier 1947. Gravure sur
bois de bout et sur bois de fil en noir, marron-
rouge et vert, imprimée à partir de trois
planches.
Andere Welt. Januar 1947. Holzstich und
Holzschnitt in Schwarz, Rot-Braun und Grün, von
drei Blöcken gedruckt.
318 x 261 mm (12,5 x 10,25'').

164
Up and Down. July 1947. Lithograph in
brown.
En haut et en bas. Juillet 1947. Lithographie
en marron.
Oben und Unten. Juli 1947. Lithografie in
Braun.
503 x 205 mm (19,75 x 8,125'').

165
Curl-up. November 1951. Lithograph.
Pelote. Novembre 1951. Lithographie.
Krempeltierchen. November 1951.
Lithografie.
170 x 232 mm (6,75 x 9,125'').

166
House of Stairs. November 1951.
Lithograph.
Maison d'escaliers. Novembre 1951.
Lithographie.
Treppenhaus. November 1951. Lithografie.
472 x 238 mm (18,625 x 9,375'').

167
[Study for House of Stairs]. 1951.
[Étude pour Maison d'escaliers]. 1951.
[Studie für Treppenhaus]. 1951.
305 x 425 mm (12 x 16,75'').

168
Relativity. July 1953. Woodcut.
Relativité. Juillet 1953. Gravure sur bois de
fil.
Relativität. Juli 1953. Holzschnitt.
282 x 294 mm (11,125 x 11,625'').

169
Relativity. July 1953. Lithograph.
Relativité. Juillet 1953. Lithographie.
Relativität. Juli 1953. Lithografie.
277 x 292 mm (10,875 x 11,5'').

171
Three Spheres I. September 1945. Wood
engraving.
Trois sphères I. Septembre 1945. Gravure
sur bois de bout.
Drei Kugeln I. September 1945. Holzstich.
279 x 169 mm (11 x 6,625'').

172
Balcony. July 1945. Lithograph.
Balcon. Juillet 1945. Lithographie.
Balkon. Juli 1945. Lithografie.
297 x 234 mm (11,75 x 9,25'').

173
(Two) Doric Columns. August 1945. Wood
engraving in black, brown and blue-green,
printed from three blocks.
(Deux) Colonnes doriques. Août 1945.
Gravure sur bois de bout en noir, marron et bleu-
vert, imprimée à partir de trois planches.
(Zwei) Dorische Säulen. August 1945.
Holzstich in Schwarz, Braun und Blau-Grün, von
drei Blöcken gedruckt.
322 x 240 mm (12,625 x 9,5'').

174 | 175
Drawing Hands. January 1948. Lithograph.
Mains qui dessinent. Janvier 1948.
Lithographie.
Zeichnende Hände. Januar 1948.
Lithografie.
282 x 332 mm (11,125 x 13,125'').

176
Print Gallery. May 1956. Lithograph.
Galerie de gravures. Mai 1956.
Lithographie.
Druckgalerie. Mai 1956. Lithografie.
319 x 317 mm (12,5 x 12,5'').

177
Dragon. March 1952. Wood engraving.
Dragon. Mars 1952. Gravure sur bois de

bout.

Drachen. März 1952. Holzstich.
321 x 241 mm (12,625 x 9,5'').

179

Belvedere. May 1958. Lithograph.
Belvédère. Mai 1958. Lithographie.
Belvedere. Mai 1958. Lithografie.
462 x 295 mm (18,25 x 11,625'').

180

Ascending and Descending. March 1960.
Lithograph.
Montée et descente. Mars 1960.
Lithographie.
Treppauf, Treppab. März 1960. Lithografie.
355 x 285 mm (14 x 11,25'').

181

Waterfall. October 1961. Lithograph.
Chute d'eau. Octobre 1961. Lithographie.
Wasserfall. Oktober 1961. Lithografie.
380 x 300 mm (15 x 11,75'').

ENDPAPERS I

One of Escher's first systematic studies for
the division of the plane, October 1936.

L'une des études systématiques d'Escher
pour la division du plan, octobre 1936.

Eine von Eschers ersten systematischen
Studien für die gleichmäßige Flächenaufteilung,
Oktober 1936.

ENDPAPERS II

Escher no. 21 [Imp]. Drawn at Ukkel, May
1938. Pencil, ink, watercolor. 332 x 242 mm
(image) (13 x 9,5''); 358 x 270 mm (sheet) (14 x
10,625'').
Escher n° 21 [Imp]. Dessiné à Ukkel, mai
1938.

Crayon, encre, aquarelle. Image : 332 x 242
mm (13 x 9,5'') ; feuille : 358 x 270 mm (14 x
10,625'').
Escher Nr. 21 [Kobold]. Gezeichnet in
Ukkel, Mai 1938. Bleistift, Tinte, Wasserfarben.
332 x 242 mm (13 x 9,5'') (Bild); 358 x 270
mm (14 x 10,625'') (Platte).